AN
ILLUSTRATED

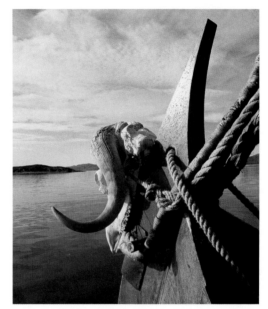

VIKING
VOYAGE

AN ILLUSTRATED
VIKING

RETRACING LEIF ERIKSSON'S JOURNEY
IN AN AUTHENTIC VIKING KNARR

PHOTOGRAPHS BY RUSSELL KAYE

TEXT BY W. HODDING CARTER

POCKET BOOKS

New York London Toronto
Sydney Singapore

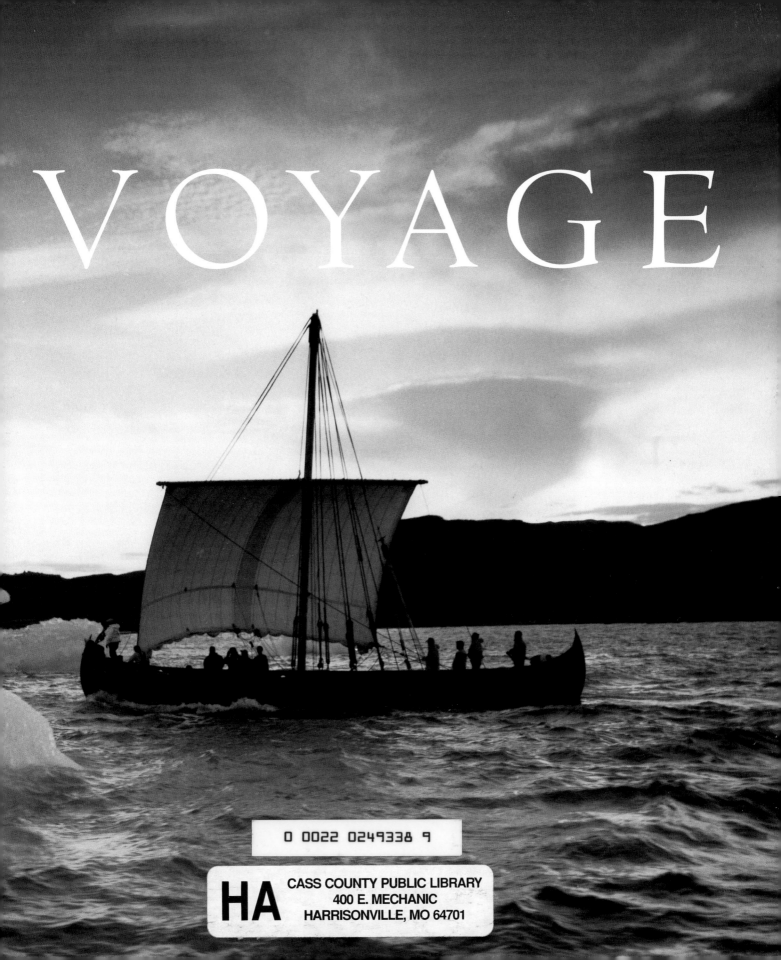

VOYAGE

POCKET BOOKS, a division of Simon & Schuster, Inc.
1230 Avenue of the Americas, New York, NY 10020

ISBN: 0-7434-0702-4

First Pocket Books hardcover printing November 2000

10 9 8 7 6 5 4 3 2 1

POCKET and colophon are registered trademarks
of Simon & Schuster, Inc.

Designed by Joel Avirom
Design assistants: Meghan Day Healey and Jason Snyder
Map by Paul Pugliese

Printed and bound in the United Kingdom
by Butler and Tanner Limited, Frome and London

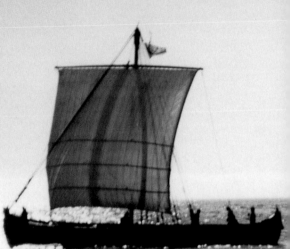

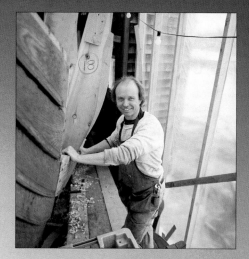

In memory of Bob Miller

ACKNOWLEDGMENTS

Behind every great coffee-table book is the family at home having to make their own coffee. While flitting around Greenland, Labrador, and Newfoundland I pined to be with my wife, Sandra-Lee Phipps, and our daughter, Lucy. This book would not exist without their love and support.

The Eastman Kodak Company gave me and this project a rather large box of their fabulous color negative films. I am deeply indebted to Lisa Johnson at Kodak Professional for her support and assistance.

The color photographs were made with Kodak's negative films in a Linhof 4 × 5 Master Technika and a Mamiya 6. The black-and-white are Polaroid's Type 55 negatives.

I would also like to thank Ewa-Marine of the Saunders Group for donating their handy waterproof housings—my cameras stayed cozy and dry.

R.K.

Thank you, Lisa, Anabel, Eliza, and Helen for your continued patience with my little adventure. I promise this is it . . . well, maybe not, but we're all going together next time.

W.H.C.

We would like to thank our agent, Sally Wofford Girand, for dinner at Nobu Next Door, and Russell would like to thank our editor, Jason Kaufman, for lunch at Shaan of India (Hodding was off dressed up like a Viking somewhere). We'd also like to thank Sally for her guidance and perseverance and Jason for making a leaner Viking story and pulling it all together.

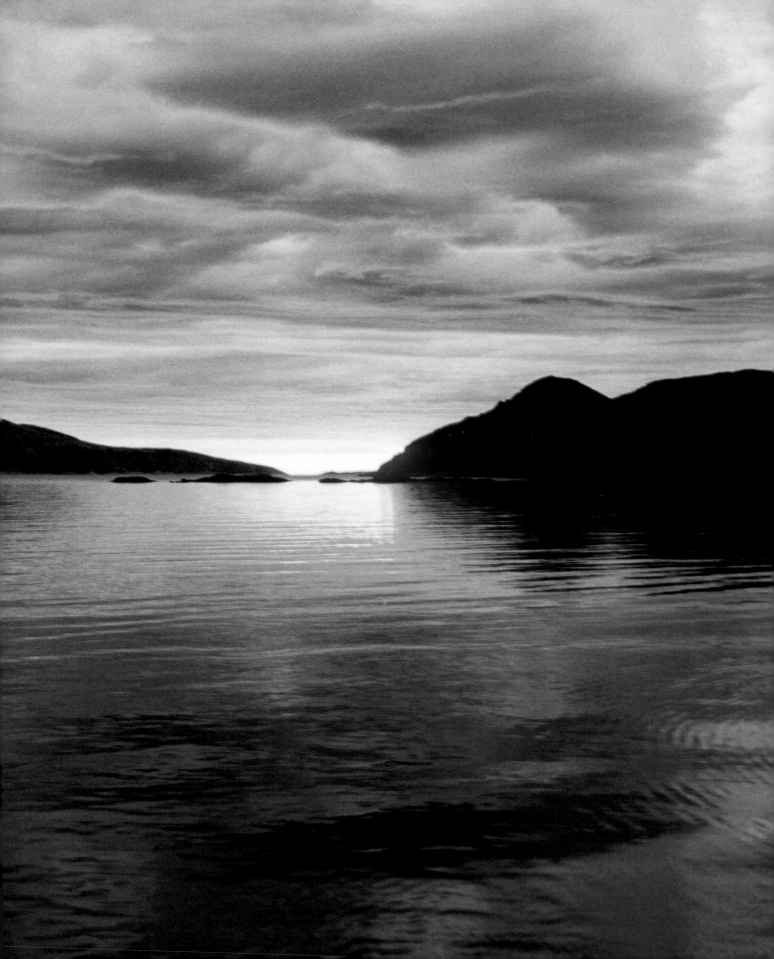

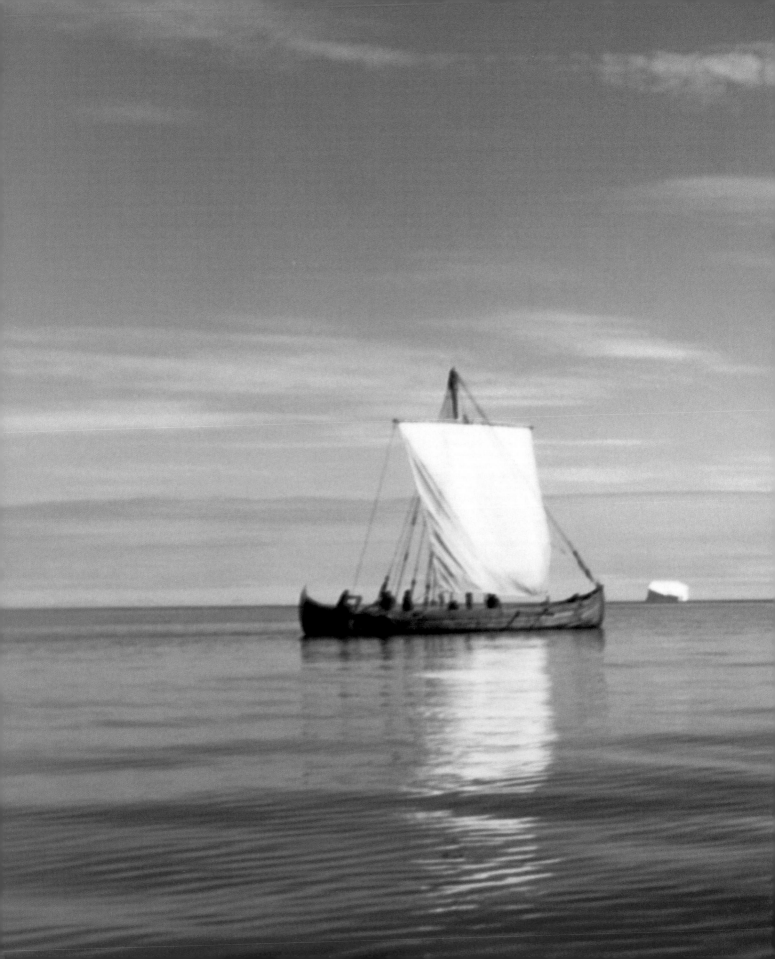

Contents

AN
ILLUSTRATED

VIKING
VOYAGE

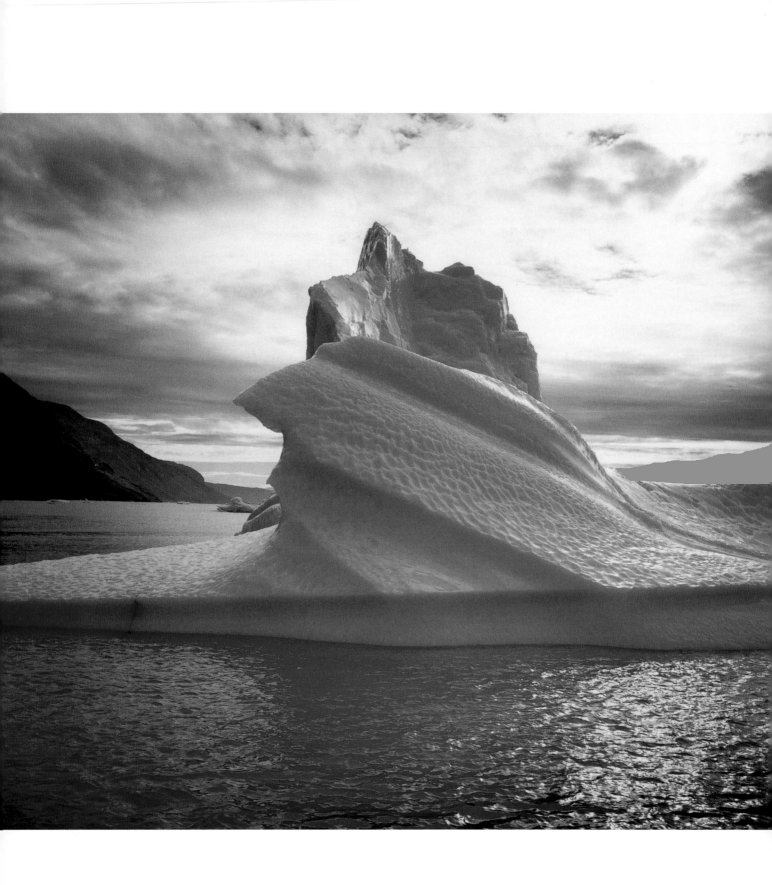

Preface: A Voyage in Time

This was a voyage about time. We sailed back in time. We fought time. We lost time. And we cursed time. In the end, however, we learned just enough about time to pull the whole thing off.

In 1994 I decided to retrace Leif Eriksson's sailing voyage to mainland North America. I wanted to look back and see how he and his fellow Vikings lived, what they felt, what they saw. I expected to find humorous situations, smelly characters, and a fair bit of danger. It would be an exciting trip, and I would have a lot to write about. It would be a lark.

I went fishing for a laugh, and instead I landed more than I ever imagined. In fact, my life was changed. I caught this change in the ocean, in the land, and even in the men I sailed with.

That is the magic of action.

The Vikings arguably slaughtered, pillaged, and burned better than anyone. Most people know this. They also built the most seductive, sinewy seacraft in the world—whether it was the battle-ready longship or the more matronly *knarr*, or merchant ship. They carved wood as if guided by some divine grace.

They even sailed for the beauty of adventure. I know this to be true, although historians will sit back and laugh at such a statement, saying, "Oh, son, you've got it all wrong. The Vikings sailed for utilitarian reasons—period. They wanted wealth, land, fame . . . They did not have time to go out for the joy of something." They're the ones who are wrong, though. That's what I have learned. All those fifth graders out there— boys *and* girls—who sit around daydreaming about being a Viking, a Meriwether Lewis, an Amelia Earhart, and only focusing on the fun of it—they are right. They know the

truth. Great things are attempted and accomplished for the joy of doing. The Vikings did have the time for this, unlike any of us today. Yes, they had to work long hours that many of us cannot comprehend simply to eat a single meal, but they also spent weeks waiting—for the weather to change, the right wind to come along, the caribou to return, their mead to ferment. While they waited, they dreamed, and then when the right time came, they lived those dreams.

The key to the difference between us and them is in their notion of time. Time was a completely different entity for them, and to follow in their footsteps, I, and the men who sailed with me, had to change our way of thinking about it. A wise man even told me this before we headed out. I nodded as if I understood, but I didn't have a clue. How could I? I was used to being able, if I had enough money or at least a working credit card, to readily get where I needed to go and, more often than not, when I wanted to. I could hop in my car—or call up an airline, a bus company, a travel agent, a friend with a car—and go. That's how life is for us. It wasn't like that for the Vikings, of

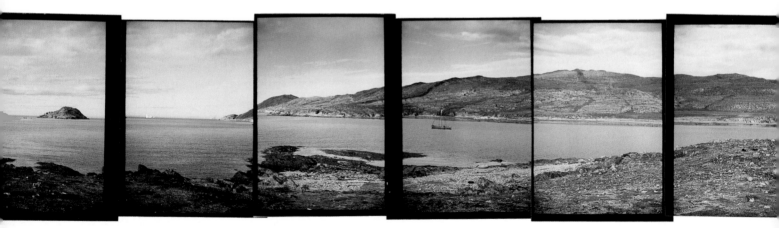

course, but I think they had as much, or even more, fun. Balancing on the floor planks of a fifty-four-foot open boat, sailing downwind in a cross sea, ducking into your woolen cape as yet another breaker crashes over the gunwale, trying to figure out how you are going to relieve yourself without falling into the churning froth, wondering if any feeling will actually return to your numb feet and hands, but feeling more alive than is humanly possible—that is what the Vikings lived for—not wealth, not fame, and not land.

In the beginning I did not know this. What mattered to me was that the Vikings were probably the first Europeans to reach the New World, and I wanted to retrace their steps.

Most of what we know about Leif and his fellow Vikings in Greenland comes from two sagas, the *Greenlanders Saga* and *Erik the Red's Saga,* written in Iceland more than two hundred years after the events they describe. The stories are not all that long, and useful information is sketchy. However, these sagas do tell us that Leif

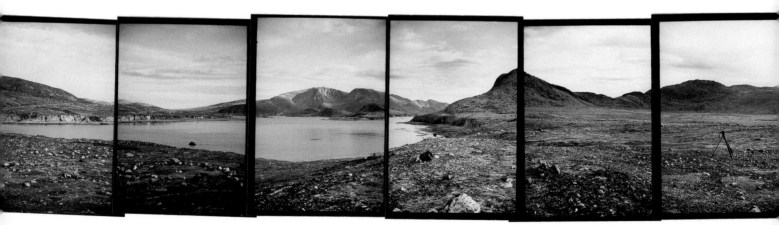

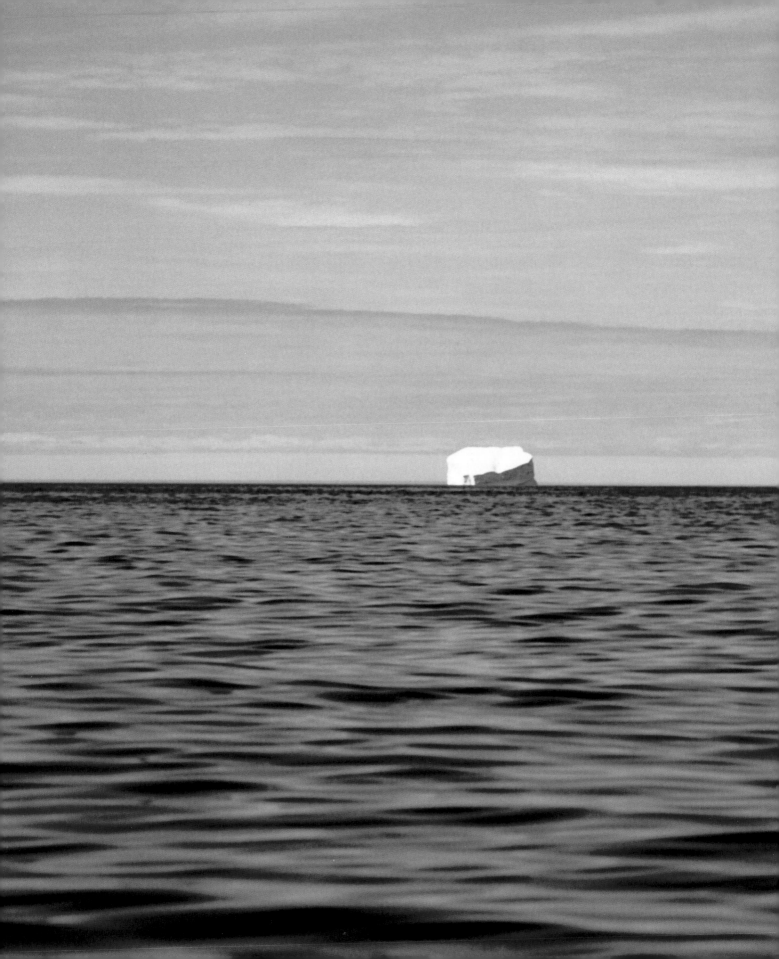

Eriksson, the son of Erik the Red, founder of Greenland, was the first European to step foot on mainland North America. In A.D. 1000 or thereabouts, Leif Eriksson was in his early twenties and ready for adventure. Living in southern Greenland, where the average tree was no taller than a man, he decided to sail west to a country that was reported to be abundant in towering forests and unclaimed land. A man named Bjarni Herjolfsson had seen this land when he sailed from Iceland to Greenland fifteen years earlier. He had been blown off course in a storm, sailing further west and south than he had intended. Bjarni had slowly sailed his way up the unknown coast until he'd reached the latitude of Greenland, and then he had sailed eastward. Leif proposed to explore these lands, to set foot where Bjarni had only looked.

He sailed west (or perhaps north and then west) and reached a worthless land, carpeted in great slabs of rock and glaciers. He called this land Helluland, or "Slabland." This has been guessed to be Baffin Island, a large, sparsely populated island in what is today Canada's Nunavut province. Leif sailed some more and eventually came to the wonderful forests mentioned in the sagas. Leif called this Markland, or "Woodland." He also remarked on the sloping white beaches within the vicinity. This area has been determined to be just south of mid-coast Labrador. He sailed on and finally came to the best expanse of all, probably the first land

that Bjarni Herjolfsson had seen. This land was ripe with salmon-filled rivers, days and nights of equal length, frost-free winters, and, best of all, wild grapes. Leif called this land Vinland, which can be translated as "wineland," "vineland," or even "grassland," depending on whom you talk with. No one has a clue where Vinland is, but it is supposedly a two-day southerly sail from Markland, according to the *Greenlanders Saga.*

In the 1960s an intrepid couple who had studied ancient maps and religiously pored over the sagas found a Viking site in northern Newfoundland at a settlement called L'Anse aux Meadows. They discovered evidence of sod huts, as well as tangible artifacts: a Viking cloak pin, a spindle whorl, and, most important of all, iron rivets and remnants from the smelting of bog iron. The couple, Helge and Anne Stine Ingstad, decided they had found Vinland.

Today, there is considerable dispute as to whether this settlement was Vinland or merely some outpost or resting stop, but it has been archeologically proven to be a Viking settlement. It is the only such settlement so far to be found west of Greenland. It would serve as my Vinland, and just as important, we would attempt to arrive there in a nearly exact replica of Skuldelev Wreck 1—a knarr that was intentionally sunk in the 1300s (to block Roskilde Fjord in Denmark from sea raiders) and painstakingly raised and studied by a fanatical group of Danish scientists in the 1960s.

After years of fund-raising, I eventually had a nearly exact replica of a knarr built by an eccentric band of traditional wooden-boat builders in Hermit Island, Maine, and the *Snorri,* named after the first Viking child born in North America, was launched on April 23, 1997.

Snorri had a few small problems from the beginning, mainly centering around the fact that she did not like to turn, but three months later my crew and I began our

journey in a small town in southern Greenland called Narsarsuaq, two miles across
Eriksfjord from the site of Brattahlid, Erik the Red's farm site. It was glorious. After
years of researching, fund-raising, gathering a crew, and having the knarr built, we were
finally on our way on July 17.

Yet, we weren't. It wasn't that easy. We had to wait and wait for the right winds,
and then slowly we rowed and poked our way out of the fjord to the ocean. It took
nearly two weeks to cover eighty miles.

It was then that we should have noticed this thing about time, how we ought to
enter a different frame of mind about time. But we didn't. We blustered our way for-
ward, failing to observe the signs that plainly said *Slow Down*. We made our way three
hundred miles up the coast to Nuuk, the capital of Greenland. We patted ourselves on
the back, and hurriedly readied for the big crossing to Baffin Island, after deciding that
we didn't have enough time to go another two hundred miles north as planned.

We sailed out into Davis Strait, and nearly one hundred fifty miles across,
smack dab in the middle between Greenland and Baffin Island, our boat began to fall
apart. Our enormous side rudder had ripped interior framing out of place, and we
immediately had four holes in the bottom of *Snorri*. Worse, because of the loose
framing, not much was keeping the stern intact. A day later, a rescue ship appeared on
the horizon. I pleaded with the Coast Guard Canada icebreaker, the *Pierre Radisson,* to
drag us to Baffin so we could make repairs and continue onward. *We have enough time,*
I nearly cried. The captain had orders to take us to the closest port, and he did—back
to Nuuk, Greenland.

Leaving *Snorri* behind, we went home to the United States chastened but, for
once, with a lot of time to set things right. We studied rudders, met with experts, trav-

eled to Scandinavia again, immersed ourselves even deeper in the project. I even had Viking clothes made to achieve a more authentic experience.

We returned to Greenland in early June 1998. Rob Stevens, *Snorri*'s builder and crew member, fashioned new framing and several spare rudders. We departed at the end of the month, from Nuuk, giving ourselves a month's more time than the previous year and a three-hundred-mile headstart. We headed slowly north, waiting and learning.

Finally, six weeks later with only two hundred more miles behind us but a newfound patience, we attempted to cross Davis Strait again. Storms were predicted, but somehow we knew this was our chance. A week later we were safely anchored on Baffin Island.

It would take forty more days to reach L'Anse aux Meadows. Our patience was further tested as we waited out adverse wind conditions and even worse, no wind at all. We rowed. We slept. We argued. But we persevered.

On September 22, three months after setting sail from Nuuk, we reached L'Anse aux Meadows. We had succeeded in our original goal. Time had slapped us across the face, chewed us up, and spit us out. It had consumed us, but we came out stronger, maybe a bit wiser, and certainly much more appreciative of the Vikings. For each of us aboard *Snorri* the Vikings had changed from rabid, foaming cartoon characters to flesh-and-blood humans. Bowing to time, we became like them, and also, we became a little bit better than we had been.

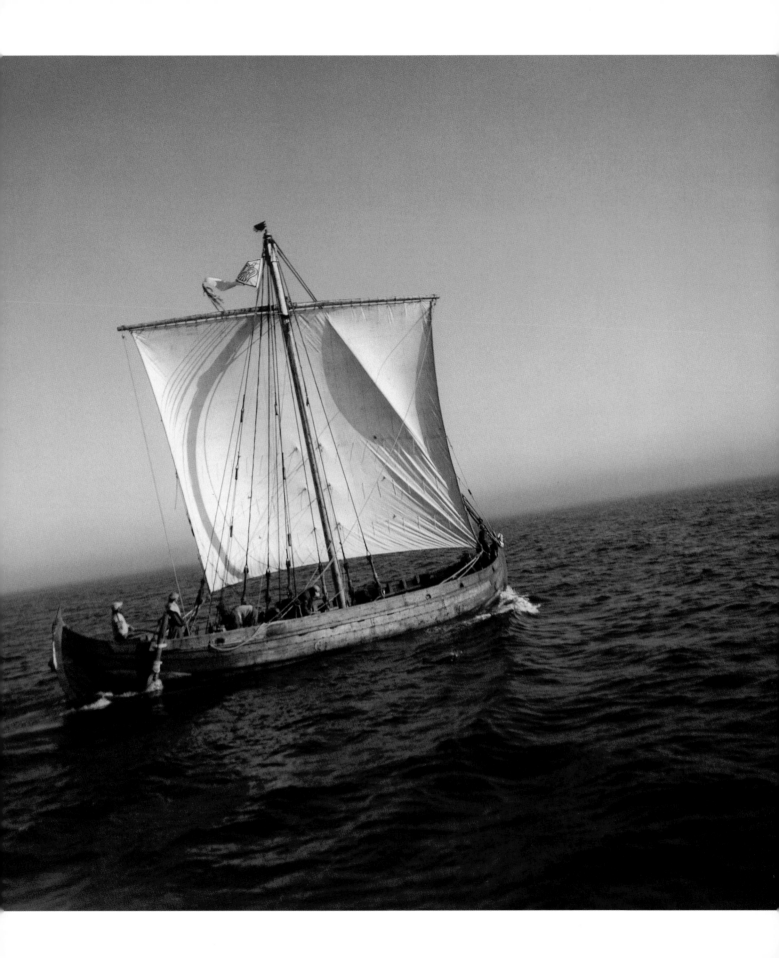

THE ROUTE
1997 AND 1998

DAVIS STRAIT

BAFFIN ISLAND

Cumberland
Peninsula

Hall
Peninsula

Frobisher Bay

LABRADOR

Nain

CANADA

L'Anse aux Meadows

NEWFOUNDLAND

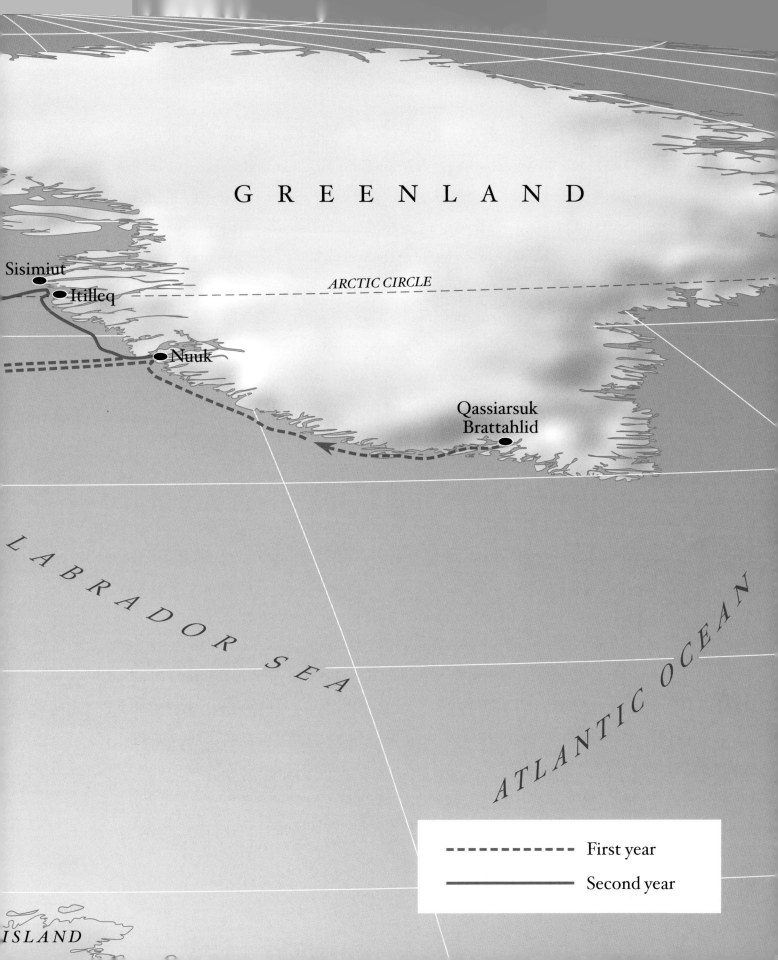

GREENLAND

ARCTIC CIRCLE

Sisimiut

Itilleq

Nuuk

Qassiarsuk
Brattahlid

LABRADOR SEA

ATLANTIC OCEAN

ISLAND

- - - - - - First year

———— Second year

LAUNCH DAY

It's a still, sunny April morning in 1997. *Snorri*, our Viking cargo ship, is resting about one hundred feet outside of Rob Stevens's boatyard, gathering her strength after a very difficult birth. The builders, dozens of volunteers, and a few future crew members labored all the previous day to free her from the boathouse. A couple of them even had to perform an emergency dismantling of the cedar-shingled building so *Snorri* could squeeze through; she was simply too beamy for the existing opening.

Now, she's about to be dragged another one hundred feet or so, down to the low-tide mark. My daughter Anabel is pouring dirt in my notebook, and her twin sister, Eliza, is screaming in her mother's arms on the other side of the boat. Both girls are wearing plastic, horned Viking helmets, and one of their first multiple-word constructions will soon be "Viking boat."

This is us; we are the Viking Family.

A crowd has been slowly gathering all morning, although we didn't advertise the launching. It's as if some little boy has run through the neighboring towns calling out, "The Viking ship is launching! The Viking ship is launching!" The people keep coming and coming—whole families with picnic baskets, the dog, and even Grandma.

This comes as no surprise. Ever since May 1996, a year ago, when I asked Rob to build this boat, people have been driving the mile-long winding dirt road that leads to the end of Hermit Island, Maine, to witness the building of this ancient vessel. The Vikings were easily the most advanced shipbuilders of their day, and when Danish archeologists recovered the sunken wreck of a knarr, or cargo ship, in the 1960s from Roskilde Fjord a half hour northwest of Copenhagen, a door was opened not only to the past but also to a greater appreciation of the skill of the Viking shipwrights.

Who wouldn't be curious to see how a real Viking boat might look? For months and months, they have stood watching—wistfully, patiently, and asking endless questions. "Why are you building such a boat here?" the casual viewer would ask. "Why are you using temporary forms instead of building by eye like the Vikings?" a more intense person would ask. In the first few months when Rob was merely lofting the plans and gathering material (and his nerve), there were only a handful of visitors each day. Rob, or one of the guys helping him, would spend half an hour discussing the merits of pine versus oak planks or the best way to set an iron rivet. They would talk until somebody nodded off, even. Each week, however, as the boat grew its curvy skin of lapped pine planking, more and more visitors stopped by to ask questions. Near the end, a scrawled sign posted outside the boathouse read in large letters, "Sorry, but we do not have time to talk."

It's been a long, anxious year, and although *Snorri* is finally about to be launched, I feel more uncomfortable than I've ever been. Reporters are drifting in and out of my life, and the publicist hired by the company I convinced to back my project shoves me in front of cameras, microphones, notebooks, crayons, at every available moment. Besides researching the Vikings, raising money, and gathering a crew, though, I have done nothing. I did not build the boat, and even worse, I have no idea how to sail it. I am not a sailor. I have even spent a good deal of my adult life avoiding sailors. They have always seemed a bit too bossy.

I want to turn to my wife for support, duck out of sight with her perhaps, but someone is interviewing her. I see Rob, the builder. We've become friends this past year, and I figure he can joke me out of my discomfort. He's got only one thing on his mind, however: Get the boat into the water. Then I see Terry Moore, the tall, confi-

dent redhead who is my captain. He's standing around with his hands jammed into his work pants, seeming nearly as uncomfortable as I.

Catching my eye and also my mood, he suggests, "Let's whip some lines." Terry has been sailing his entire life. I found him through Maine's Hurricane Island Outward Bound School, where he has been an instructor for nearly ten years. He's as comfortable around boats as I am around daydreams.

"Sure," I answer hesitantly, thinking we're going to look mighty odd standing on the dock flaying our rigging against granite blocks while the builders are doing real stuff, like pounding in last-minute hand-forged iron rivets, but at least we'll look nautical. I do not have a clue as to what whipping entails, but I grab a rope and prepare to swing.

Terry pulls out two needles, a coil of twine, and two leather sewing palms and sits cross-legged in the dirt. "Oh," I mutter, and quickly plop down next to him. "I've never whipped a rope before."

He carefully shows me how to wrap the twine around the line and then sew it through the wrap to make an end that will not fray. I begin whipping, engrossed and thankful for something to do.

Before I get even one whipping complete, the publicist grabs me for an interview. Terry is explaining to somebody what we are doing, and I glance back at him as I walk away. "So this is how it is," his face says, and then I'm hauled behind a huddle of reporters.

A few hours pass this way. I'm pulled in every direction. Terry stands around waiting, concerned that no other crew members have bothered to show up for the launching. Rob rushes around, throwing steel rollers in front of *Snorri*'s keel for her to continue her stately descent to the water, occasionally pitting his entire body against the twelve-ton boat to slow it down. I have asked Rob to be a crew member, thinking

that if he's willing to sail her into the Arctic, then the boat has got to be safe. Watching him now, I'm feeling less than reassured, especially knowing that he refers to the knarr as *the Kevorkian*.

Snorri eventually reaches the low-tide mark. Now we just have to wait a few hours for the tide to return.

My wife, Lisa, and I head into Rob's boathouse for lunch and a break from this moment. Lisa has always been my coconspirator, but lately she's been relegated to the role of supporter, sideliner, and mother. She is the one who initially challenged me to build a Viking boat. I was just going to travel up to Greenland and bum my way through Leif Eriksson's route. All people want to know from her now is how it feels to have a husband like me. "Are you worried?" they ask, smiling. She dutifully answers the questions and says she is extremely worried, which she is. At night, she even cries about what might happen to me. It is not a light matter, this matter of her husband intentionally risking his life and the lives of others for adventure. Her feelings are no cliché. But I also know she is feeling jealous and even left out. Of the two of us, she is the one who burns more brightly with the desire simply to do, no matter what the cost. Yet, here she is, playing the poor, housebound wife, worried to death about her husband's safety. I can't do anything about it, either. We have two toddling girls and are expecting our third baby in four months.

We eat hurriedly, restlessly.

When we emerge from lunch, the crowd has grown larger. A few strangers approach me, pat me on the back, congratulating me. One guy even gives me a cigar. To the very last minute, this has been a community project—not just the area surrounding Hermit Island, but the greater community of the state. People have sent cards. Written letters. Brought school buses. Donated wood and even ballast stones. Given of them-

selves, as well as plenty of unsolicited advice. There seems to be an ownership by the community of the project. Even the governor, Angus King, stopped by to watch *Snorri* grow, bringing along a box of doughnuts to encourage the builders. In that regard, it makes sense that nearly seven hundred people are happily standing around, waiting to see a fifty-four-foot wooden boat float.

To these people, this project is not about the Vikings and especially not about the book I want to write. It is about carrying on a nearly four-hundred-year-old tradition of Maine boatbuilding. The first seagoing boat ever built by English colonists, the *Virginia*, was launched about three miles from this spot in 1607, and the people of Maine have been turning them out ever since. The art of building traditional wooden boats—all these people seem to be saying—as opposed to fiberglass or plywood ones, may be dying out, but it is not dead. And it certainly is not forgotten. I realize unexpectedly that this is not a crowd of sightseers. It is, pure and simple, a gathering of believers.

We walk toward the harbor, and Terry is standing in the bow all by himself. His hands are crossed, but he no longer looks ill at ease. Water is lapping *Snorri*'s sides for the very first time. What a nice steady sound. Life aboard *Snorri* is going to feel and sound good. A dream runs through my body. I slough off all my worries and climb aboard, remembering at some point to help Lisa and the girls over the sheer plank— the top plank of a ship.

It smells divine. For the past five months, *Snorri*'s woodwork has been slathered in a mixture of pine tar, turpentine, and linseed oil to protect and cure the wood. Pine tar is made by heating pine until a natural tar oozes out of the wood's structure, and hence, it smells of fire, smoke, and long days spent outdoors. It is an intoxicating aroma, and we breathe it in as the water rises higher and higher.

Any minute now, *Snorri* will be floating. As the tide rises up the hull, a few leaks sprout up between strakes, but nothing that cannot be slowed with a wedge of canvas. *Snorri* will never completely stop leaking, even sucking in hundreds of gallons in rough seas, but within a few days the intake will slow to a trickle as the wood swells with water.

Terry begins telling some of the builders what he wants them to do once we cast off and explains his rowing commands: *give way* means row forward; *come to oars* means cease rowing and lift your oar out of the water; *hold water* means keep your oar in the water but don't row, among others. I listen carefully, not wanting to mess up. We have decided to row out a few hundred yards into the harbor and then row back—more for the crowd than anything else. The mast won't be stepped, or mounted, for a few days, so unfurling her billowy sail is not an option.

More and more people crowd on board—friends, builders, and total unknowns. Someone asks me if it's okay for them to be there, but what do I know? We've only got life vests for twenty, and at least sixty people are bouncing on the floorboards. Gerry Galuza, the blacksmith who has forged more than three thousand of the boat's iron rivets, climbs aboard, looking proud and outlandish in his faux Viking helmet. Dave Foster, the seventy-something builder who taught Rob how to build boats, chases about twenty people off a crossbeam that looks ready to snap. Then, a wet-suited diver pops up near the bow and says *Snorri* is free of the bottom. A small cheer goes up.

Somebody hands Lisa a champagne bottle wrapped in a cloth napkin. A bouquet of wildflowers is tied to the stem. Everyone and everything grows quiet, except for the soft, persistent lapping against *Snorri*'s sides. Lisa takes a powerful swing and the glass shatters across *Snorri*'s bow.

We are off.

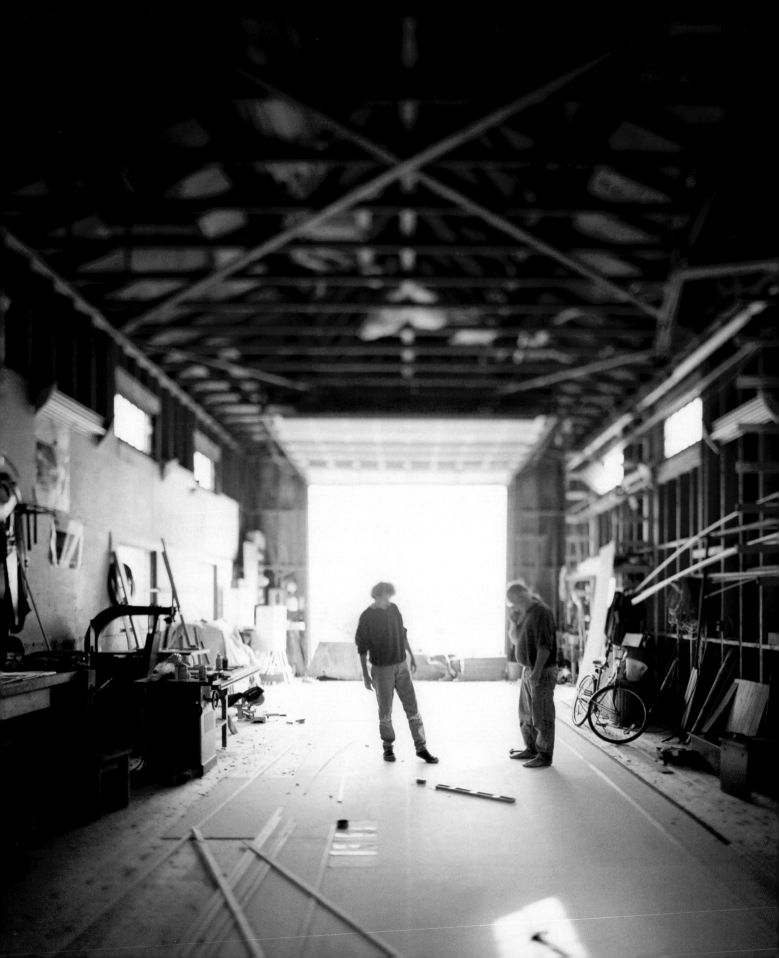

Rob Stevens (right) *and Scott Smith ponder the lines of the Viking ship to come.*

RIGHT:

Rob did whatever it took to get the right wood for the knarr—even chop down his own trees.

BOTTOM:

Natural bends were needed for rigorous curved framing.

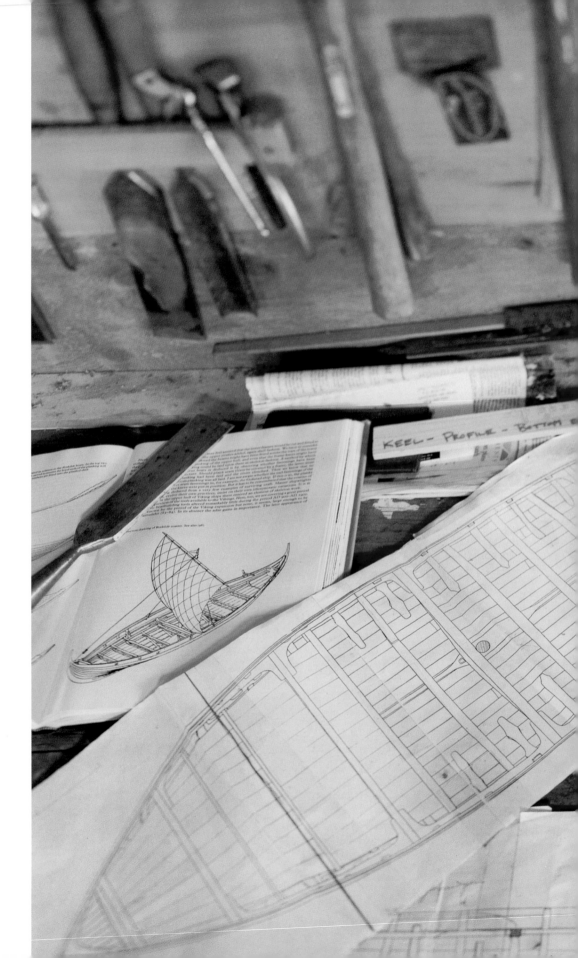

Tools of the trade.

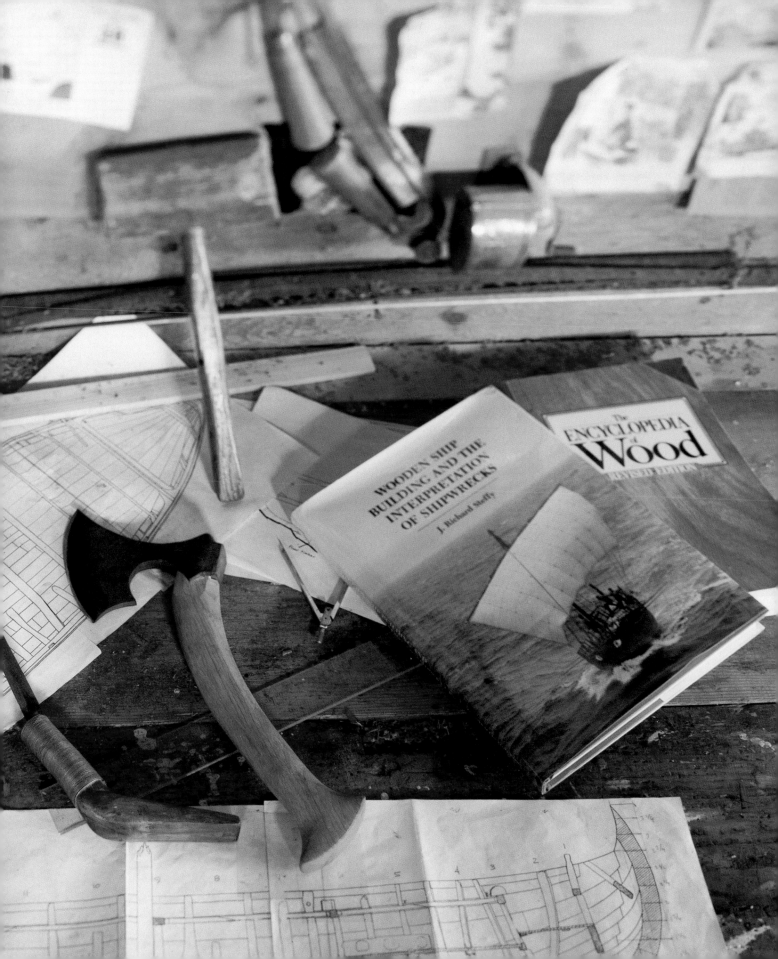

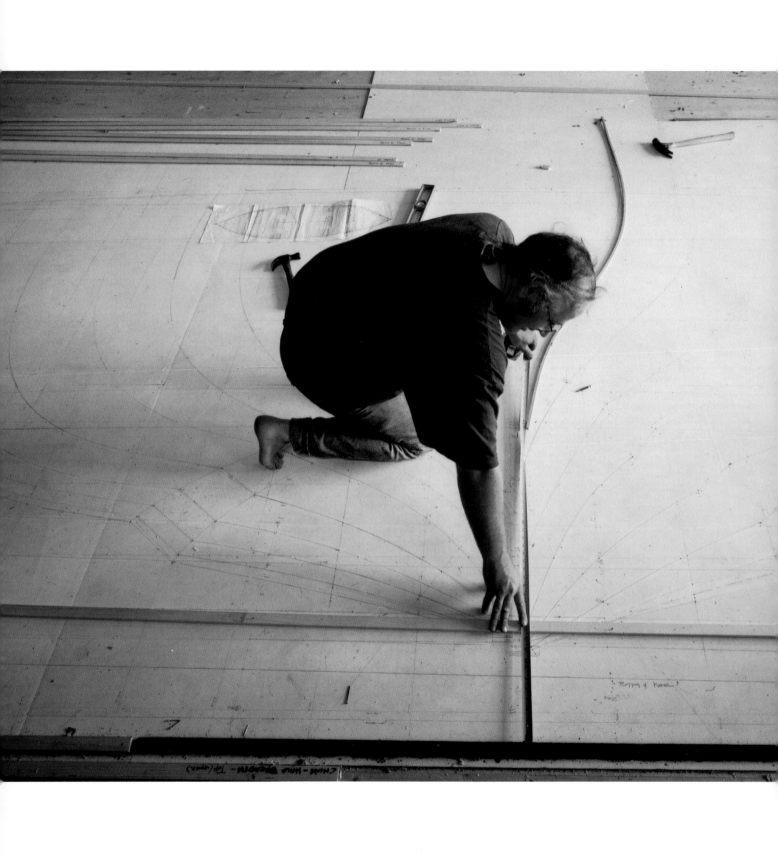

OPPOSITE:

The Vikings built by eye, but modern-day builder Rob Stevens decides to draw out a full-scale version of Skuldelev I.

RIGHT & BELOW:

Temporary molds provide the correct shape for Snorri's hull.

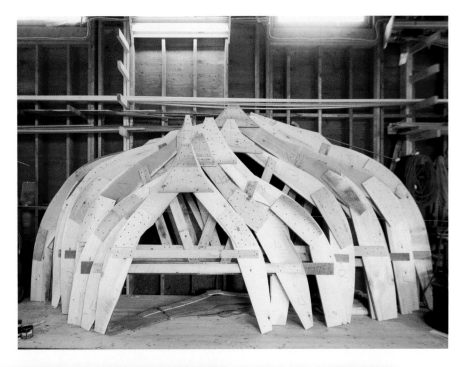

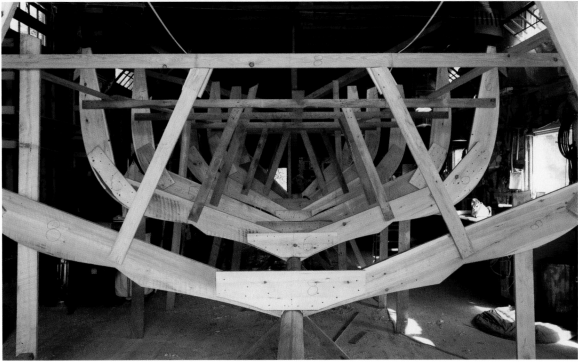

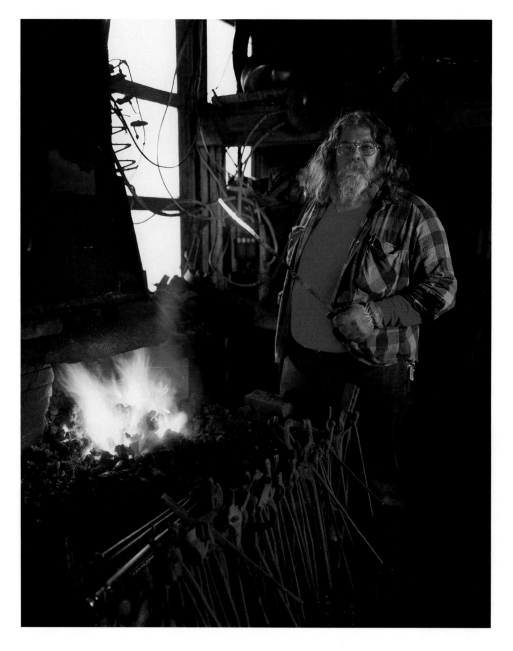

ABOVE:

Gerry Galuza, traditional blacksmith, forged nearly three thousand iron rivets to hold Snorri *together.*

OPPOSITE:

Many of the rivets were forged by hand, but most were sped along with the use of a trip-hammer.

OVERLEAF:

With keel and molds in place, the ship takes shape.

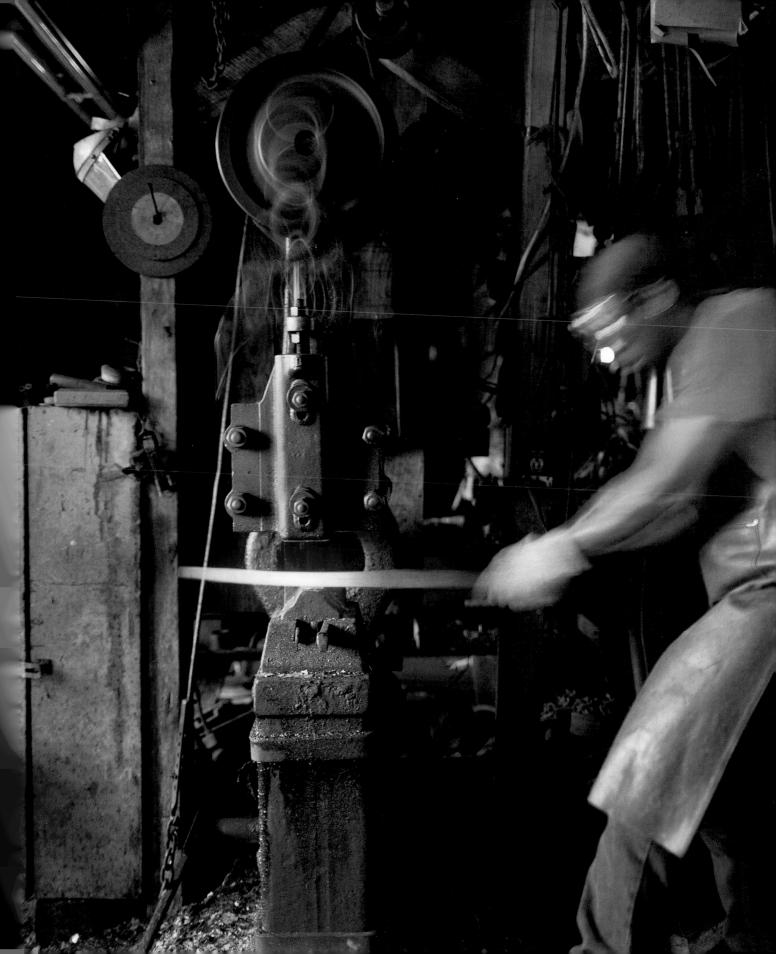

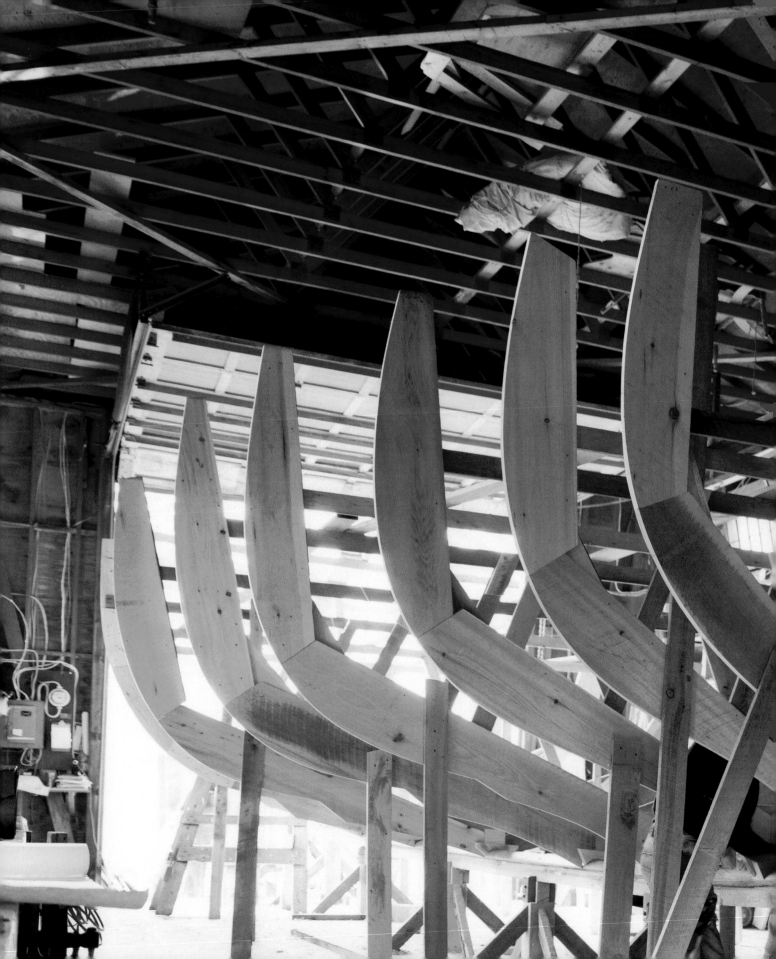

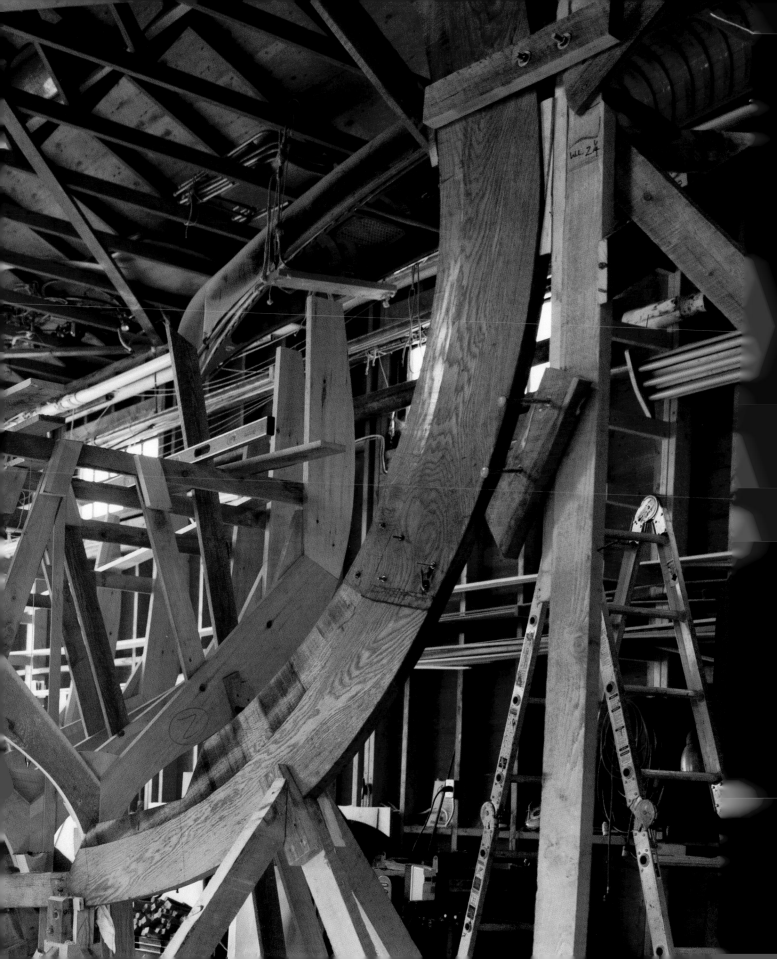

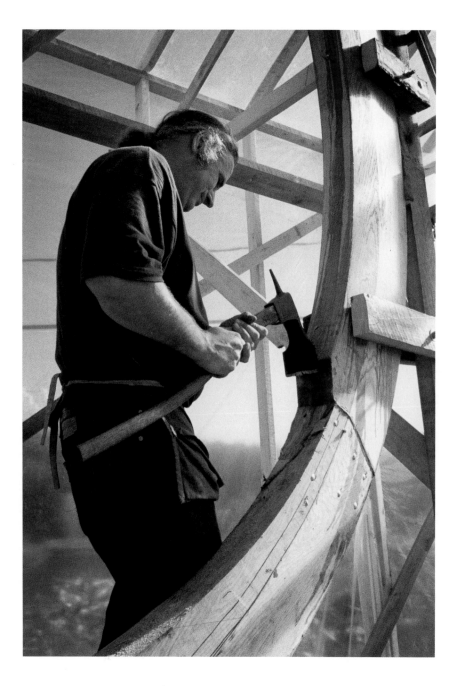

LEFT:

When it came to fitting everything together, traditional tools proved the most useful.

BELOW:

A few weeks before launch day, and our deadline loomed.

OPPOSITE:

The boatbuilders (left to right): *Scott Smith, Bob Miller, Deirdre Whitehead, Lee Houston, John Gardner, and Rob Stevens*

SORRY, BUT WE DO NOT HAVE TIME TO TALK

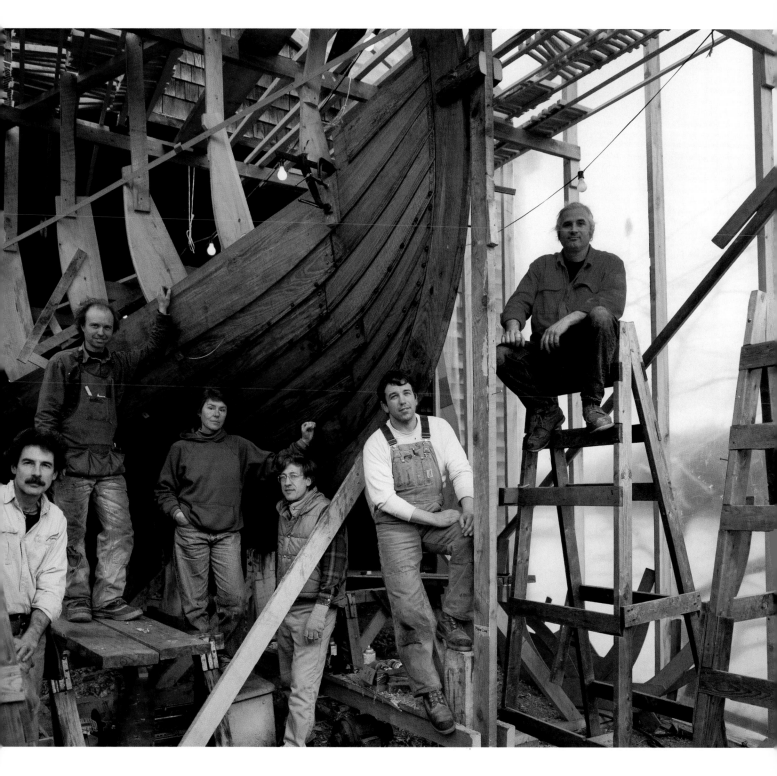

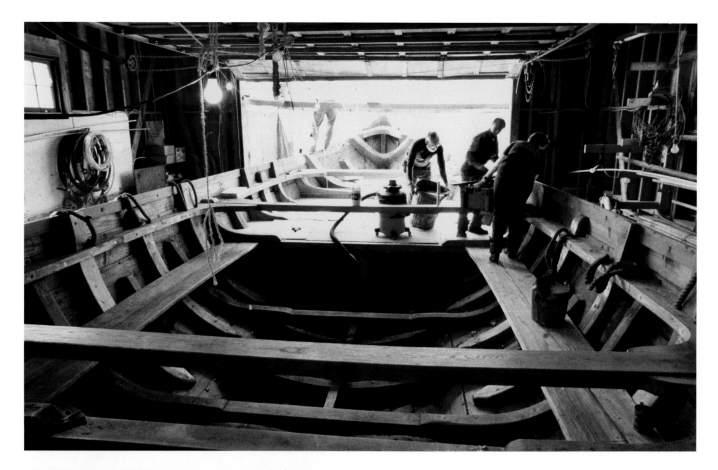

ABOVE:

Did the Vikings use Shop-Vacs?

LEFT:

A bucket of pine tar: loathed by some, revered by others, the viscous substance protects wood, rivets, and rigging.

OPPOSITE & OVERLEAF:

A fifty-four-foot ship doesn't quite fit a forty-five-foot boat shop.

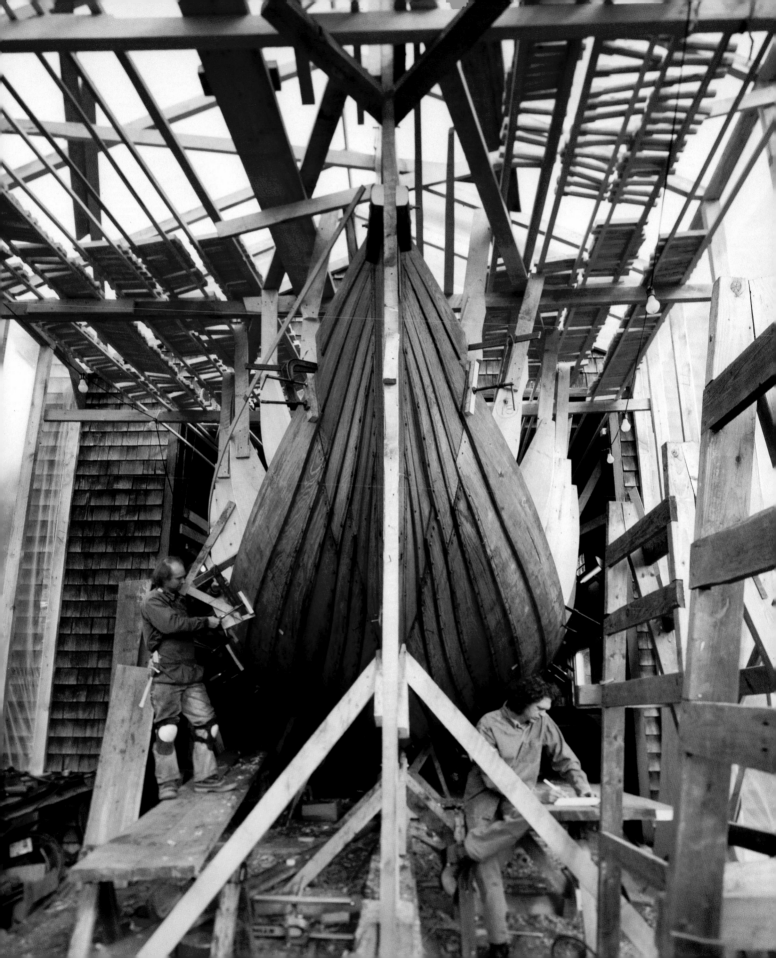

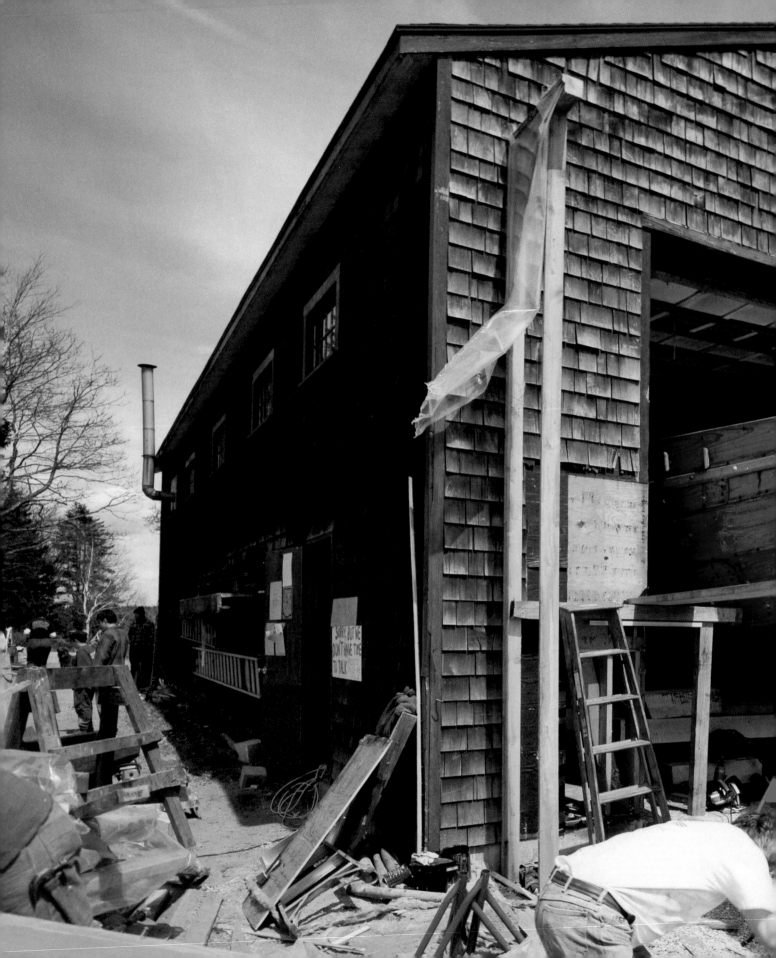

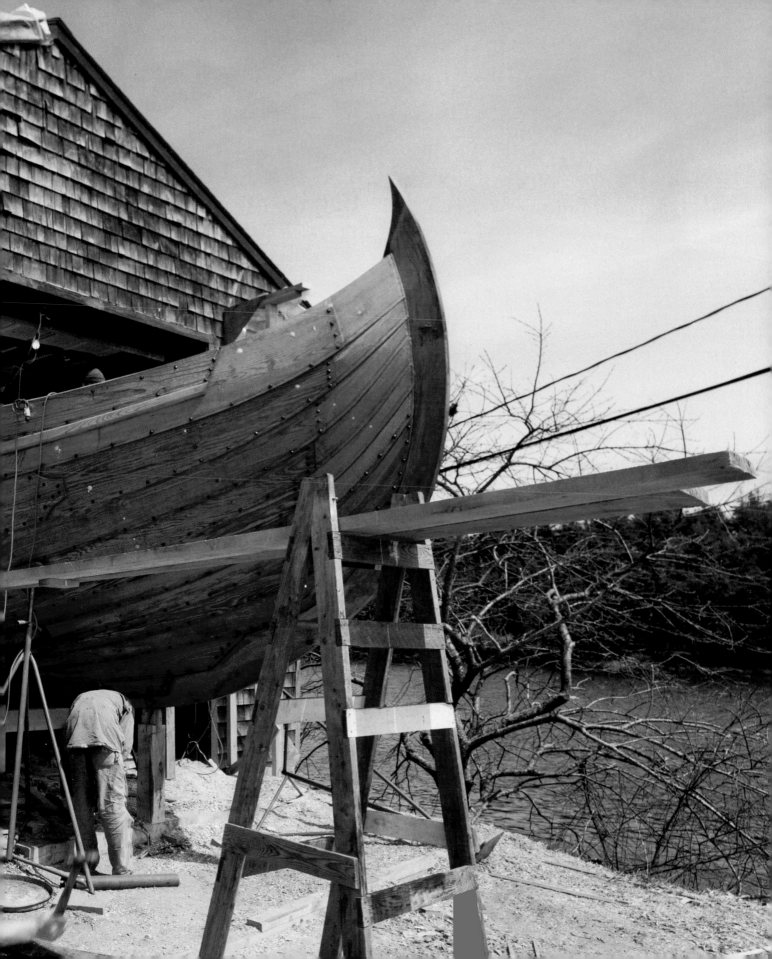

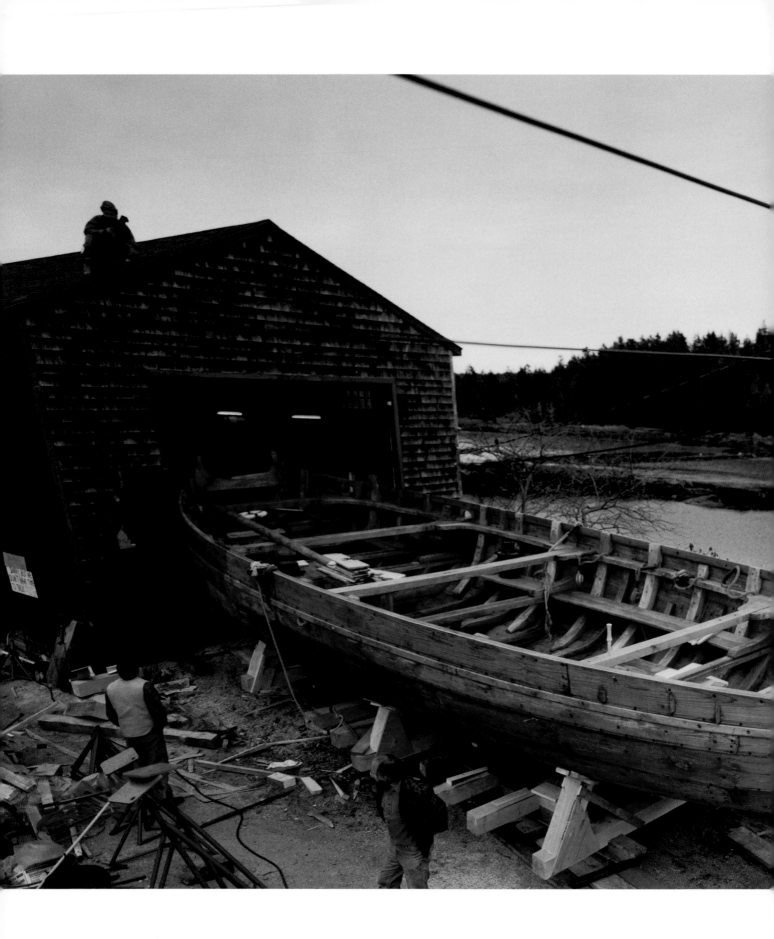

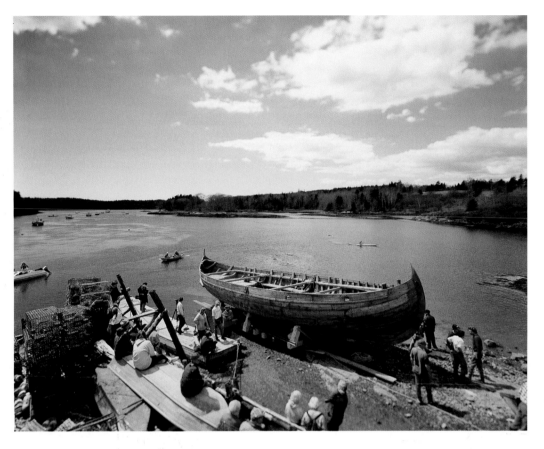

LEFT & ABOVE:

It took two days to drag Snorri *one hundred yards from boathouse to water, but now she's just waiting for the tide.*

OVERLEAF:

Snorri *floats!*

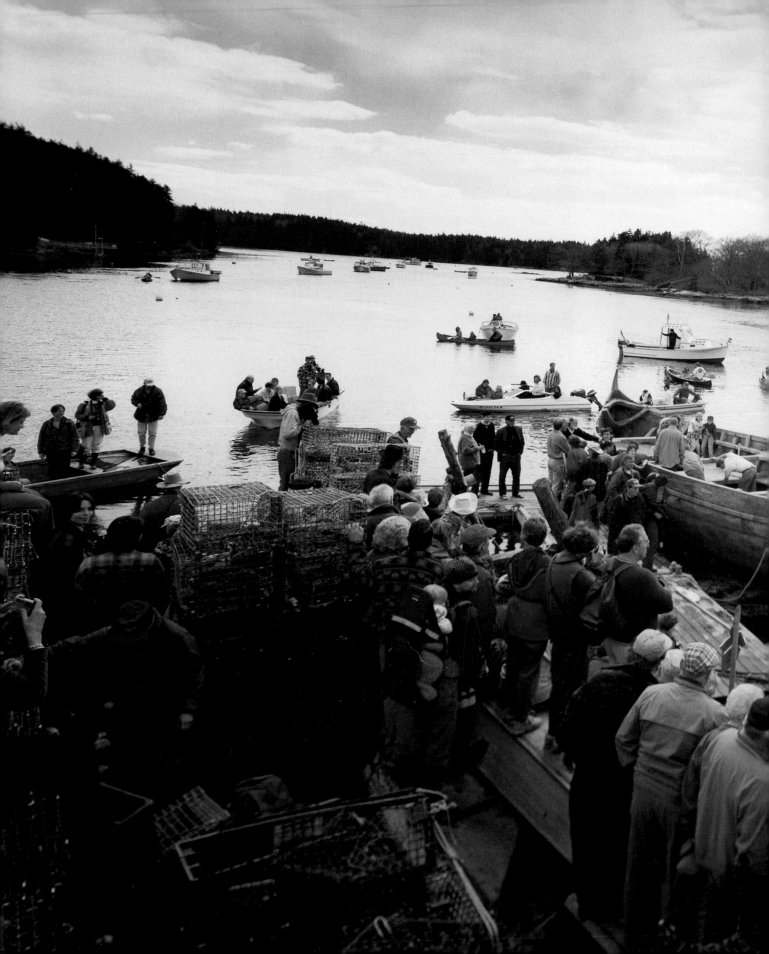

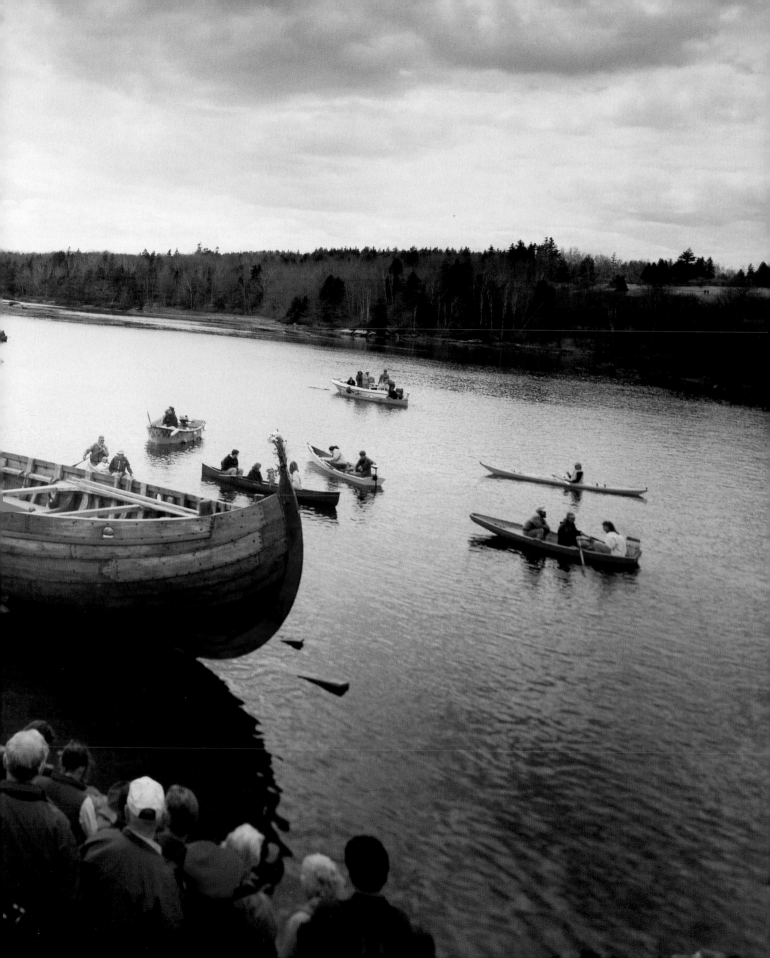

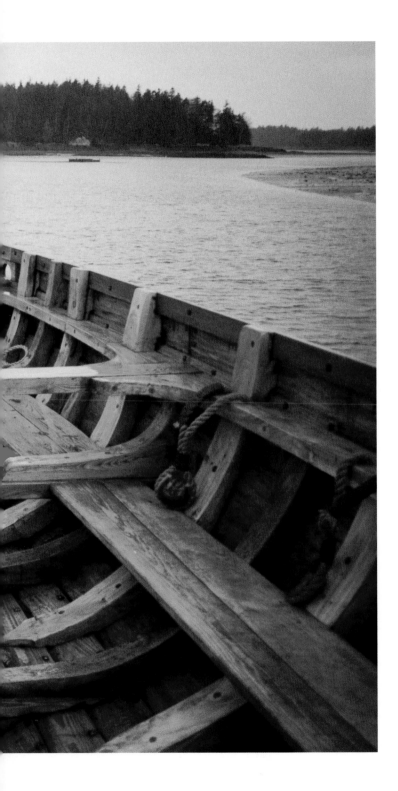

Minus her forty-three-foot spruce mast and fifteen tons of rock ballast, Snorri *looks more like an overgrown canoe than a Viking knarr.*

BELOW:

Hermit Island, Maine

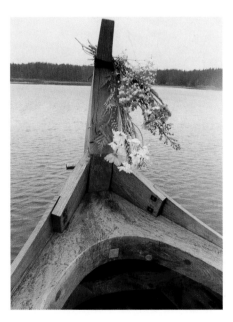

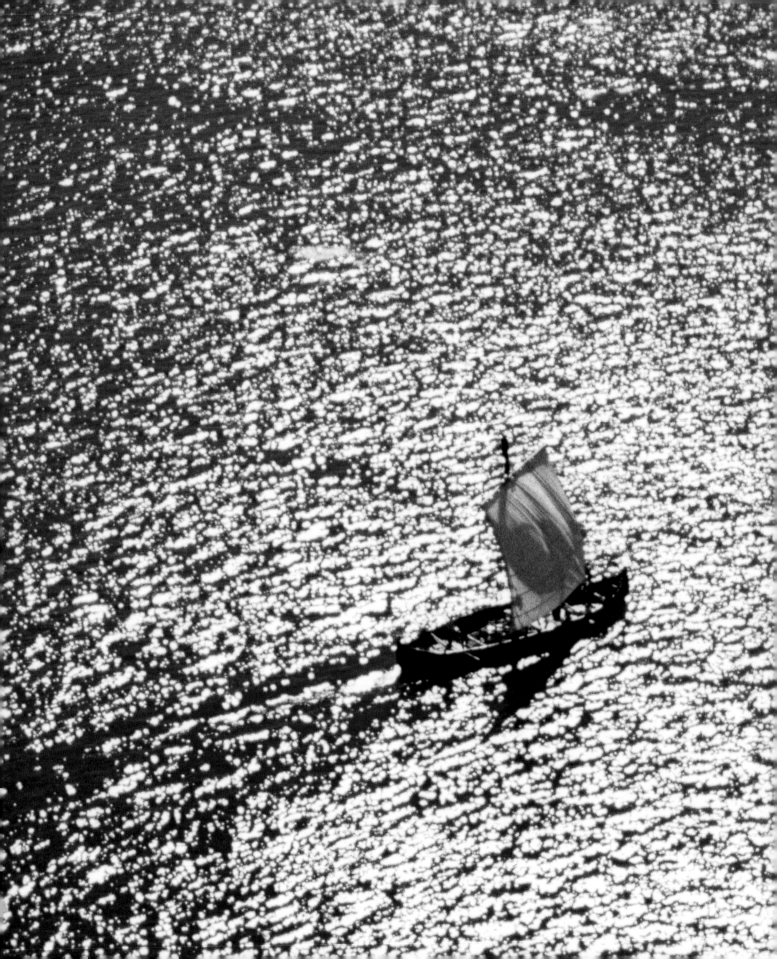

GREENLAND

This has got to be the worst place in the world. I am on bow watch. I am wet. I am cold. I am exhausted. The wind is blowing off our port quarter. We're almost sailing downwind, but the 1000-square-foot sail has a way of funneling the air and increasing its speed, redirecting it straight down on the bow watchman—one of a thousand funny little tidbits that were not passed down through the various Viking sagas.

Half the crew is asleep; half is on duty with me. They are all counting on my spotting the unseeable growlers that race by our hull. Growlers are chunks of iceberg that range from basketball-size to larger than a grand piano. Though small when compared to a 150-foot-tall iceberg, growlers can easily splinter our thin hull. They float just beneath the surface, except for sharp pinnacles or glistening sheets rising inches above the water, and it feels as though they have been set loose to destroy us. It is four A.M., and although the sun has loped above the horizon, the light is hazy and unclear. It does not help matters that I have not slept more than two minutes all night.

I fall asleep standing. A second later my neck folds and then snaps back to attention. I think I hear my dad admonishing me. I concentrate on my numb feet, hoping that some internal whining will keep me alert. My feet are numb because we have sailed into the wind all night. Despite what some enthusiasts might espouse, Viking boats do not sail well into the wind. They can do it, mind you, but they do not get anywhere. A night's continuous sail has only garnered us four miles north, although we have covered nearly thirty miles tacking, but even worse, it has worn us down to nothing. For much of that time we have been sailing into a twenty-knot wind in roughly thirty-five-degree weather.

It has taken us two weeks to get where we are, which is a few miles north of southwest Greenland's Cape Desolation, and I'm thinking about renaming it Cape Disconsolation. We've averaged six miles a day since embarking from Brattahlid, Erik the Red's old farm site in what is still referred to as Eriksfjord. I had thought we would average closer to fifty miles a day when I dreamed this whole thing up because knarrs are capable of averaging a speed of ten knots. It didn't help matters that we sailed one hundred miles in twenty-four hours when we took *Snorri* from Hermit Island, Maine, to Boston to deposit her on a containership headed for Greenland, via Iceland. Given that experience, I thought my expected average of fifty miles a day seemed reasonable, but I had not counted on the dreaded fjord effect. In the summer, it seems, the wind in southwest Greenland blows up the fjords, toward the island's ice cap, if it blows at all. As a result, we have had to do a lot of rowing, since tacking against the wind gets us nowhere. Our top speed when rowing is one knot.

To keep myself awake, I try to figure when we will arrive in L'Anse aux Meadows, Newfoundland. Originally, I had guessed the end of August or early September 1997. My new calculations put us there closer to May 30, 1998. Of course, we would all be dead, having tried to sail through an Arctic winter in a boat that has no cabin and no protection from sea ice, but given our current progress, that is the best we can hope for. Something has to change.

Seeing a nasty growler off the port bow, I yell out instructions to head toward starboard. The helmsman obliges, and I glance back at the destructive ice. It was a mirage. There is only water.

A few hours later, we finally row into a protected anchorage behind a thirty-foot-high natural jetty. After we set the anchor and prepare *Snorri* for sleeping, which

includes raising the tarp that stretches from the bow to the mast, Terry slumps against a knee and announces aloud, "That was awful, guys." Immediately, the entire crew lets loose a torrent of curses and complaints.

When things subside a bit, Jan, our lawyer-cook from New York City, asks Terry, "So, is that offshore sailing?"

"Yep."

"Well, I can certainly see why you love it so much."

Things do change, though. The wind starts blowing from the south, and we cover more than two hundred miles in five days. It is all downwind sailing, and it is nearly spiritual. Some days, we are making such headway that you can feel the hemp rigging straining mightily to keep sail and boat as one. The sail fills with so much wind that it seems as if we might take to the sky. We are living a fairy tale—everyone's child-hood fantasy of sailing. Have sail, will travel. What had seemed hopeless only days before now seems possible. We are going to make it.

We slap each other across the back and gladly sail through the night again and again.

OVERLEAF:
There was nothing Snorri *liked more than a following wind.*

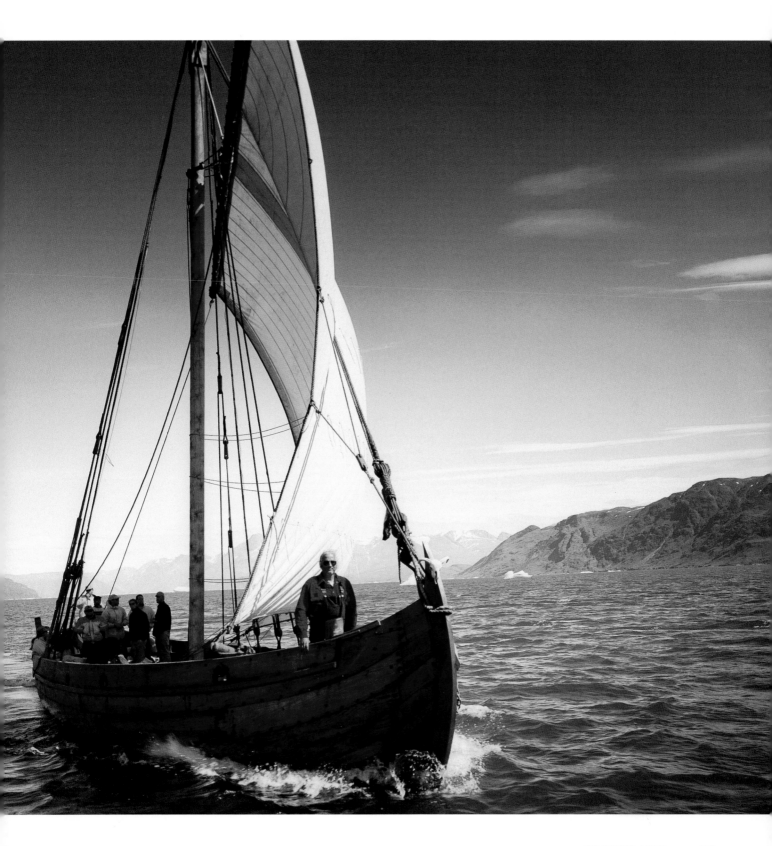

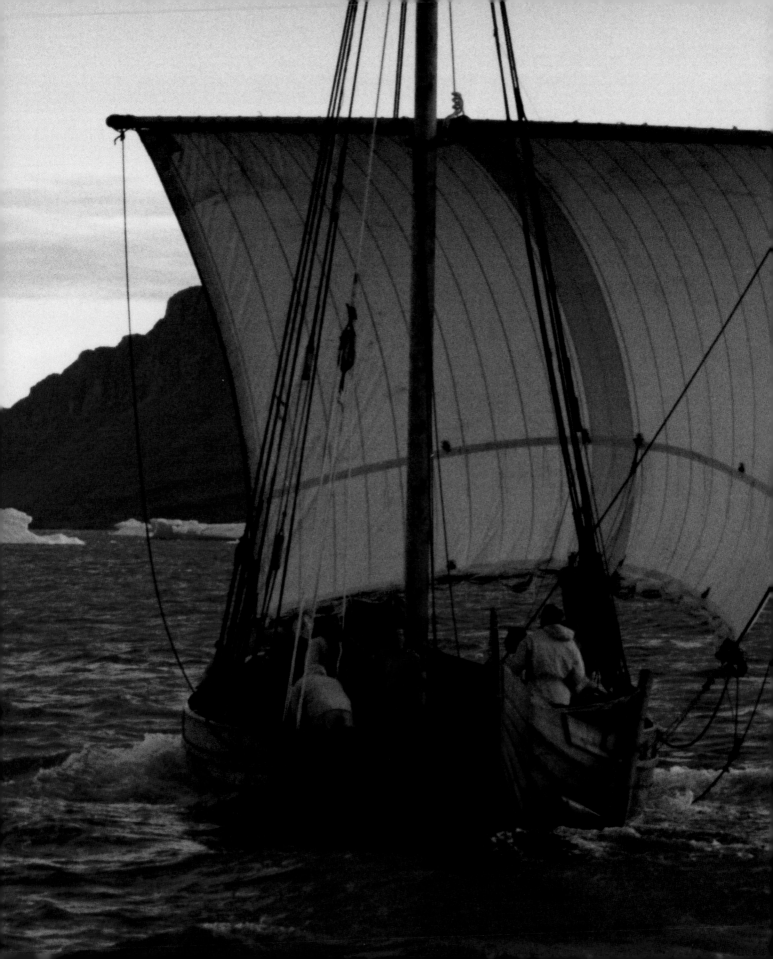

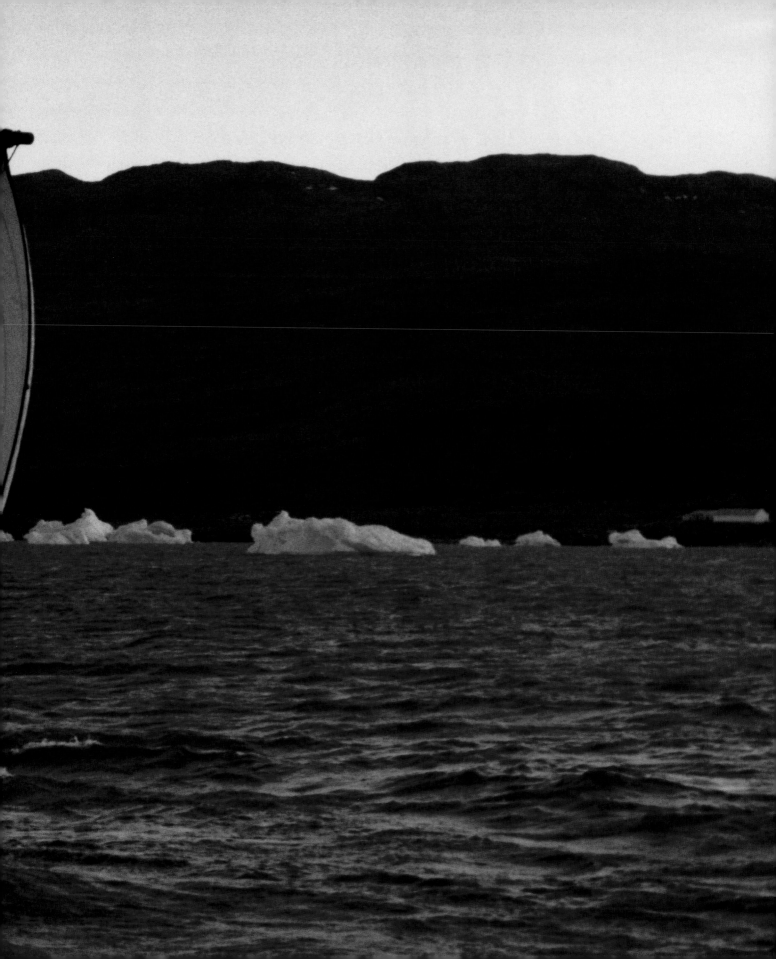

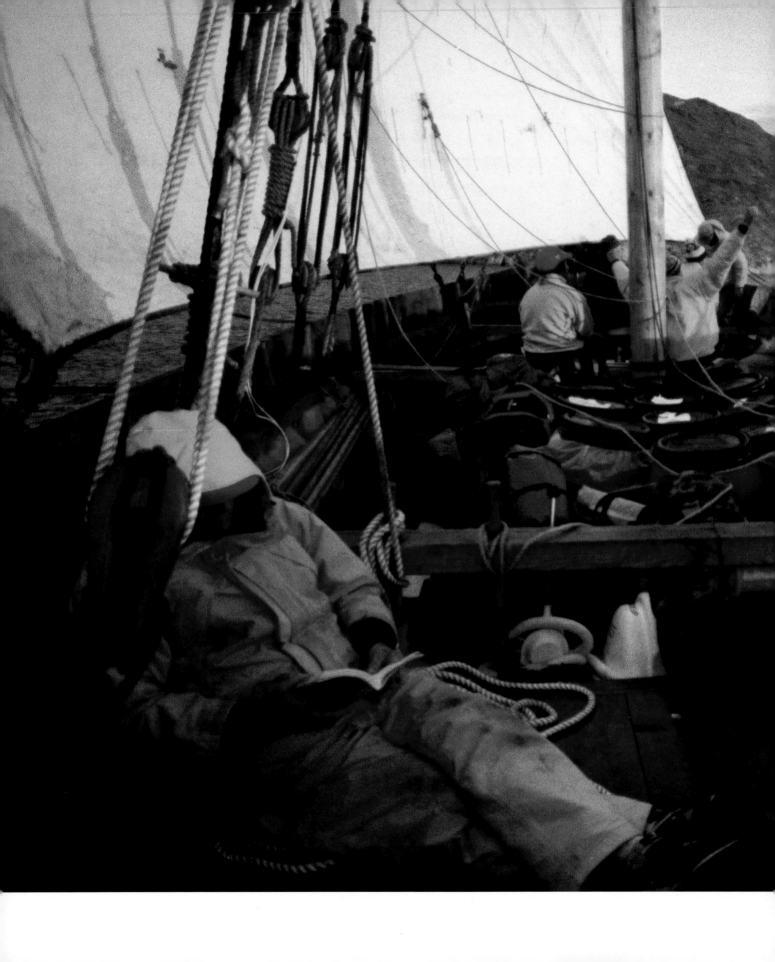

Snorri *could sail into the wind, but it took endless tacks without any real forward progress. Time to read, snack, or consider whether Leif brought his ship all the way up the fjord in the first place.*

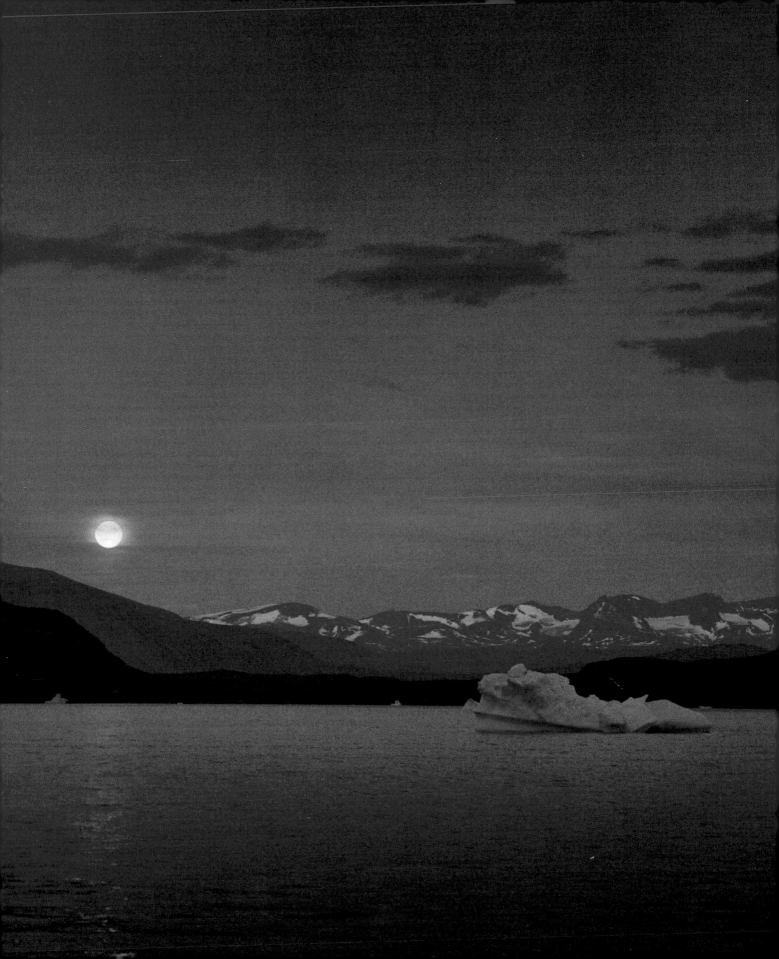

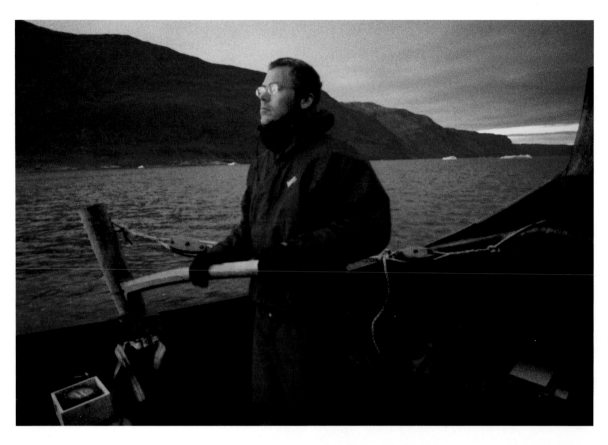

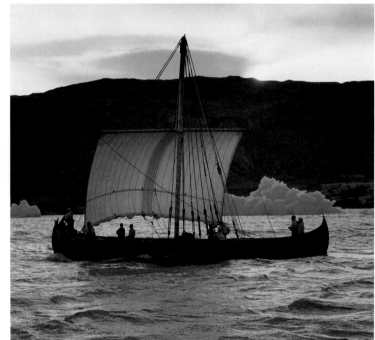

OPPOSITE:
Midnight. Darkness finally falls. The sun will return in four hours.

ABOVE:
Erik Larsen mans the tiller in Eriksfjord.

RIGHT:
Dodging icebergs outside of Narsaq, Greenland.

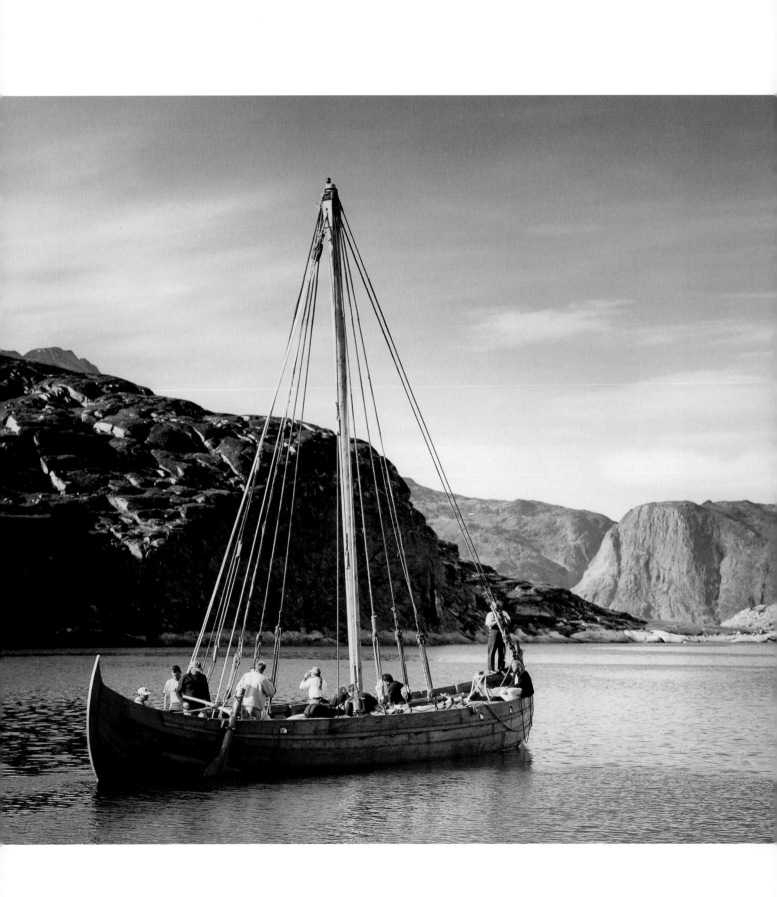

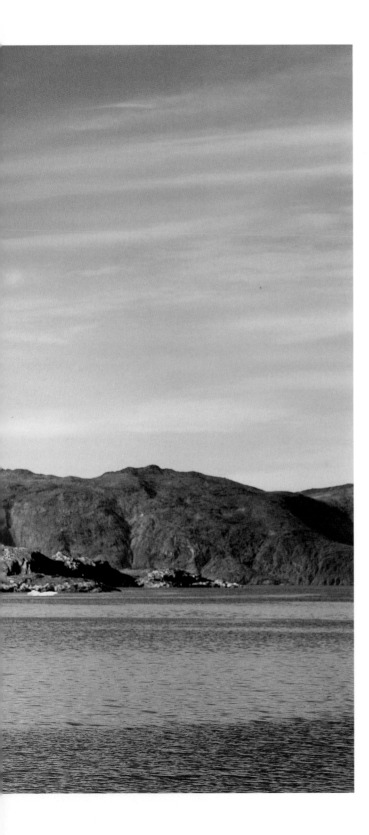

LEFT:
Snorri *is rigged with pine-tarred hemp;
the Vikings would have used walrus skin
or horsehair cordage.*

ABOVE:
*The fearless leader retrieves a stove part—
an item a day was lost overboard.*

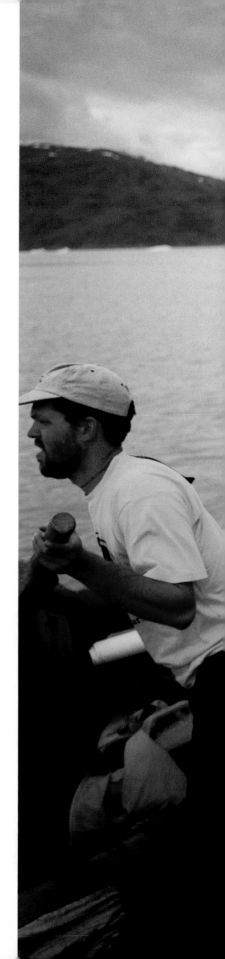

It took ten days to reach the ocean, mostly rowing. We had expected to be hundreds of miles up the Greenland coast by then.

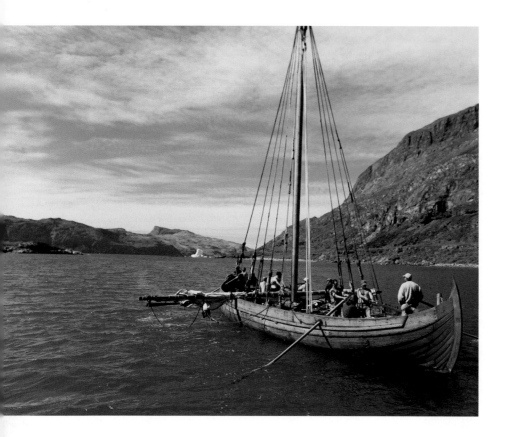

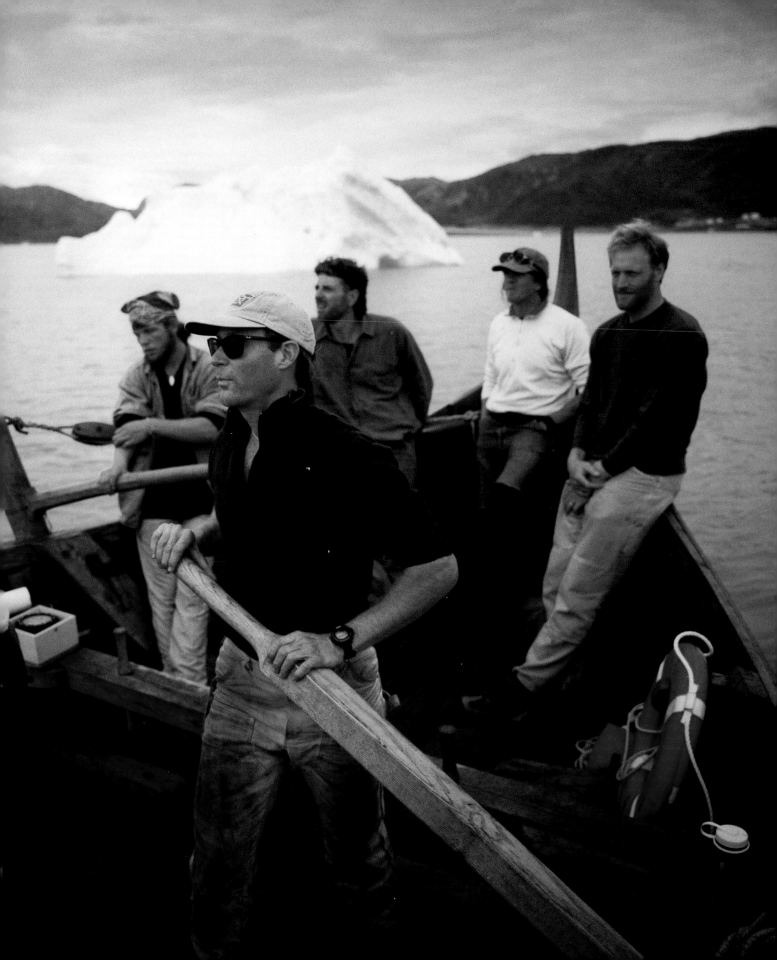

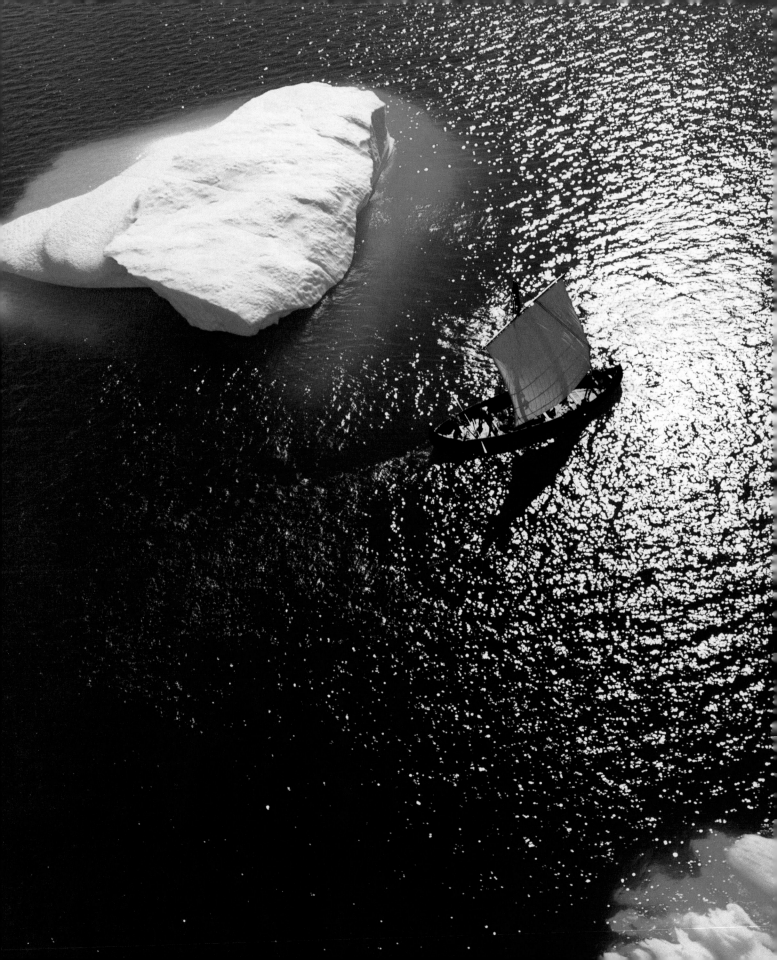

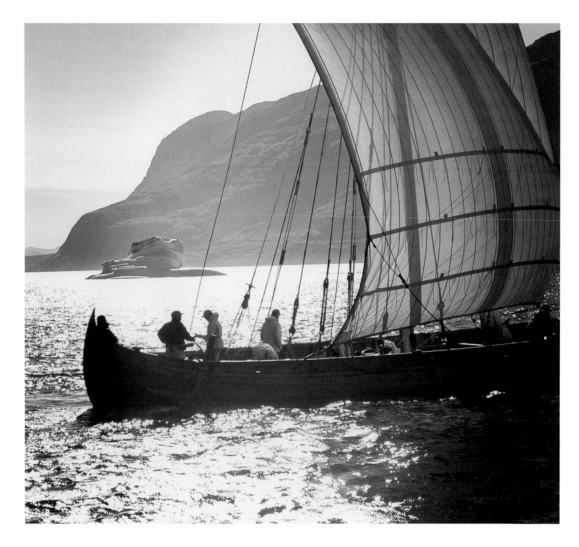

LEFT:

These icebergs in southwest Greenland drifted hundreds of miles from the island's east coast.

ABOVE:

It took five crew members to stand watch: three to work the forward part of the sail and stand bow-watch, one to steer, and one to handle the sheets and braces.

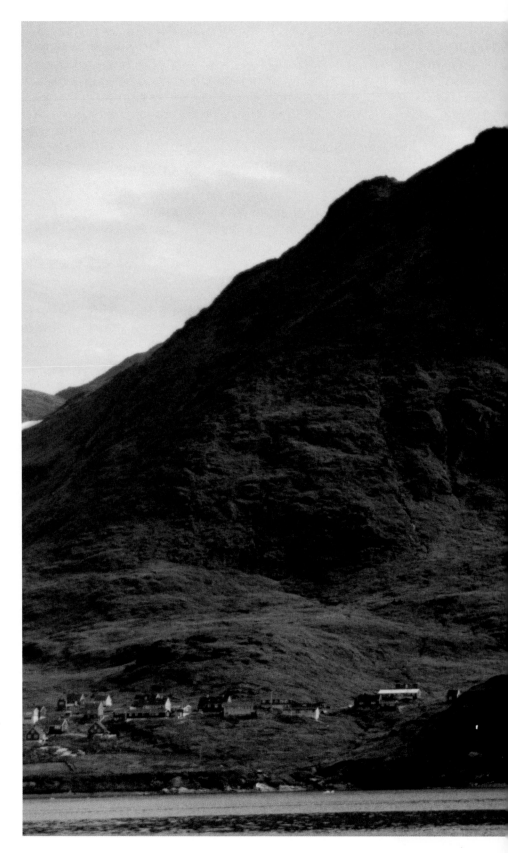

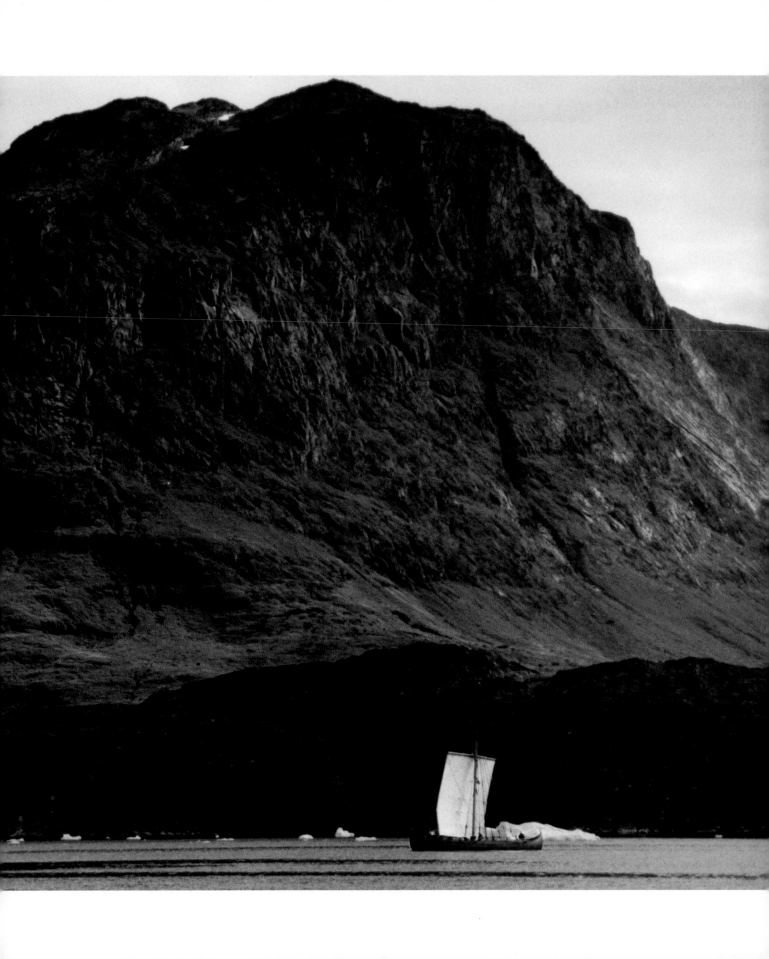

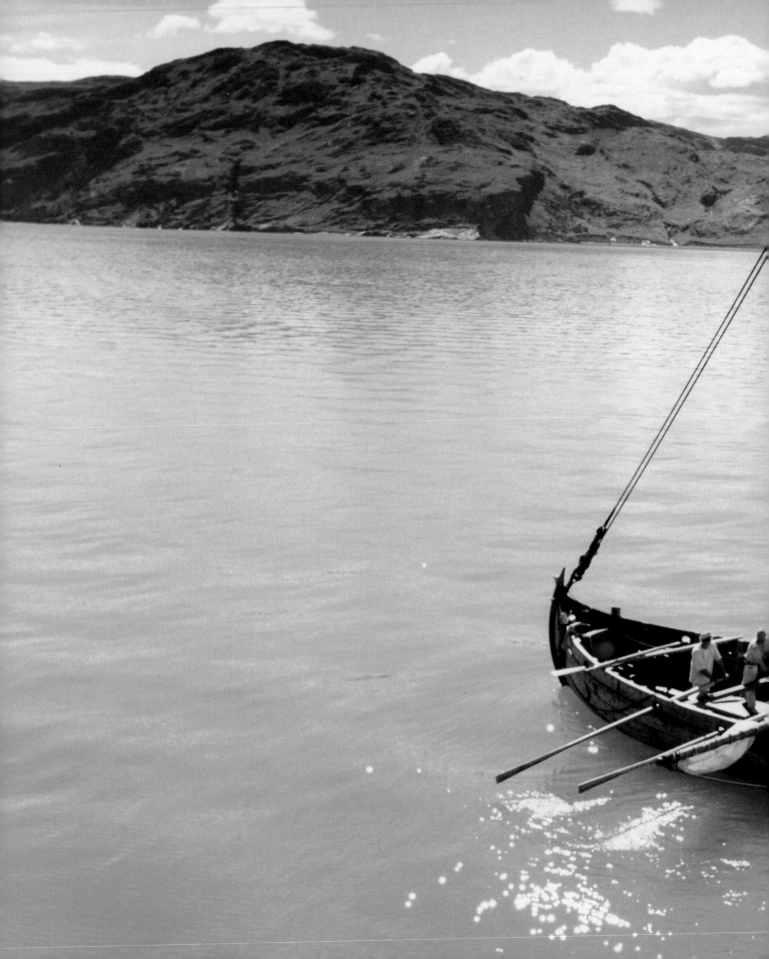

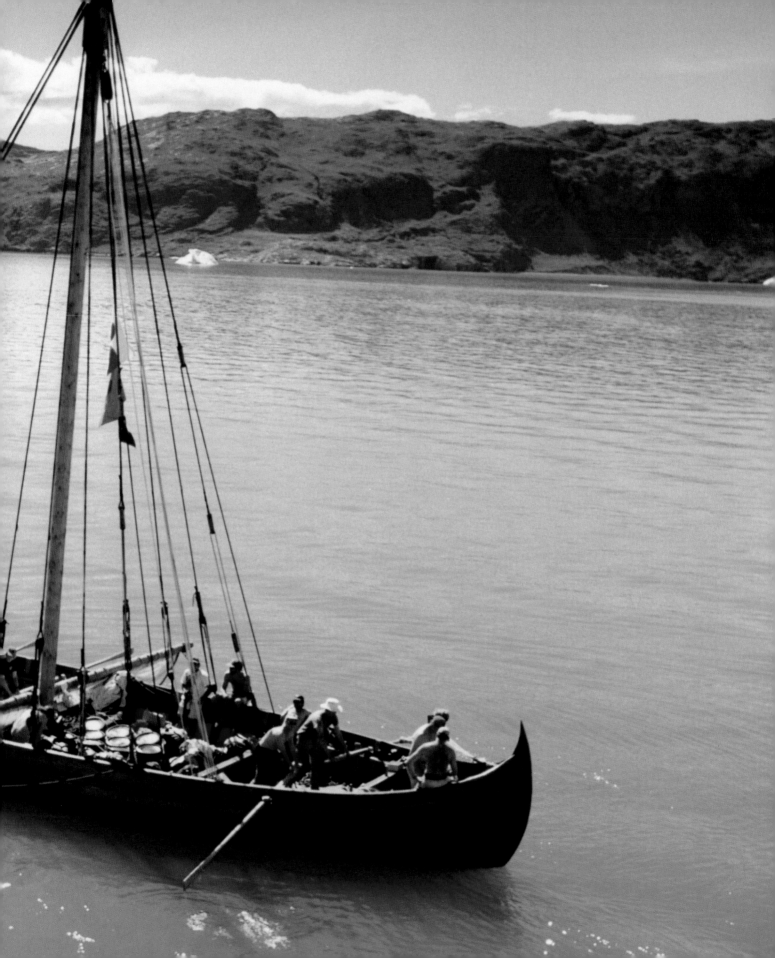

ASHORE

Greenland is like a birthday present given half a year early—surprising, delightful, and wondrous. I never expected such splendor from a land all but covered by ice, yet it repeatedly commands our attention as we sail up the coast.

We are not always sailing, though. In fact, we spend half our days on land. We go ashore not necessarily by choice, although twelve guys confined to roughly five hundred square feet, day in, day out, need time apart. We anchor because our wind either dies or turns to the wrong direction, the boat needs repair, we need to resupply our water from meltwater streams, or, quite often, we simply need to sleep. No matter how tired we may be, however, we rush to land, while one or two of the crew stay aboard to protect *Snorri*. Marauding icebergs might crunch her side. The ship might slip her anchorage and drift ashore. Or, even worse, *Snorri* might float out to sea, leaving us stranded. So two of us usually stay with her, keeping a watchful sleep or, better yet, trading shots of whiskey while playing cards.

The landing party rows the inflatable dinghy to the boulder-strewn shoreline, and we momentarily remain huddled together. Invariably, something attracts our collective attention. A minke whale skull, picked clean, waiting to return to the sea. Reindeer scat, indicating that perhaps the reintroduced animals are making a come-back in southern Greenland. A clump of tangy mountain sorrel, providing a refreshing break from our canned and reconstituted meals. Then we see the less expected: a human artifact. We spin vainly in our tracks, glancing across the horizon, wondering where these predecessors possibly came from. The answer, of course, is that they came from the water, just like us.

This rugged coastline, which can be uninhabited for a hundred miles or more, always gives up some sign of man. (We hardly ever happen upon strands of hard plastic

or Styrofoam refuse here.) It's uncanny, but nearly everywhere we go ashore, people have been there before. Stone foundations, tent rings, midden mounds, even graves, slowly reveal themselves beneath our feet.

Although it appears that most of these deserted anchorages have not seen people for decades or perhaps a hundred years, the land feels watched or perhaps protected. The sentinel-like graves spy on us from surrounding hilltops. They are made of rock slabs shaped around the deceased and are covered with scaly lichen. Often the graves are caved in, having long given up their residents' souls. They are placed up high, we are told, so the dead can always see who is coming. We do not linger beside these grave stones for long, perhaps fearing our presence will shatter their languorous hold upon the land.

We move back down near the shore, back down to the tent rings. They capture our attention the longest. Relatively small stones, each not much larger than a man's fist, form a circle ten to twelve feet in diameter. The stones once held down skin walls that were held erect with whalebones and bits of driftwood. All these years and they still sit, waiting for the hunters to return.

I sit in the middle and imagine the meals that once were—whale, seal, or caribou eaten raw or cooked over a soapstone burner, ignited by rendered whale fat. Perhaps the entrance flap is down to keep out the bugs and the light is dim. My mouth waters for *kiviaq*, a traditional dish made by stuffing unplucked, uneviscerated guillemots in a seal-skin, then allowing all to ferment beneath a rock covering for several weeks.

Two days later, we've sailed one hundred miles and tie up at a dock. Fishing nets lie piled high on it as we climb off *Snorri*, and at first we cannot see the town. Then, it lies before us, each house the color from a rainbow but even more vivid and alive. The

paints and building materials come from Denmark and other European countries, but the squat houses don't look out of place. The Greenlanders opted for wood, metal, and vinyl decades earlier, using skin and peat only in their dreams.

We rush to the local store and buy ice-cream bars and a Greenland brewed beer; fermented guillemots are a thing of the distant past, too. The towns have satellite dishes, E-mail, and today, world cup soccer blaring from every open window. It is a modern land . . . yet, it's not. No roads lead from one town to another (an old joke on me, since I once imagined hitch-hiking from town to town to retrace Leif Eriksson's journey). Dogs can be heard howling from nearby islands where they are kept in the summer; they are sled dogs, only needed in the winter. Wooden sleds wait under porches for the snows to return. Fish hang drying in the sun.

Our world and theirs are separate, though, until the children find us. They come running unheeded to the docks, stare for a moment, and then with a simple welcoming gesture from us, come clambering to our sides. We give them a yo-yo; they give us candy. We show them how to raise the yard; they teach us the Greenland words for *fish*, *knife*, *hello*. Then their parents or other relatives come to fetch them. Soon, we have thirty visitors milling about. We speak haltingly in broken English until someone translates. A few people invite us into their homes; others content themselves with sitting on a crossbeam, patting *Snorri*'s wooden sides, dreaming. I think many of them want to come with us, though only the children ask.

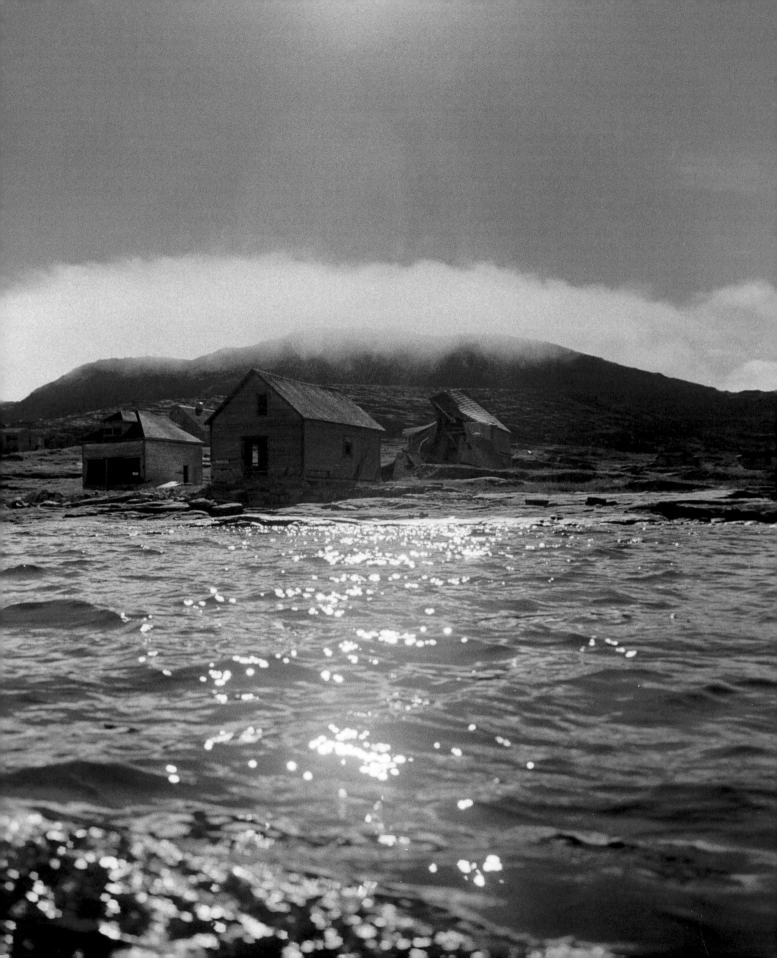

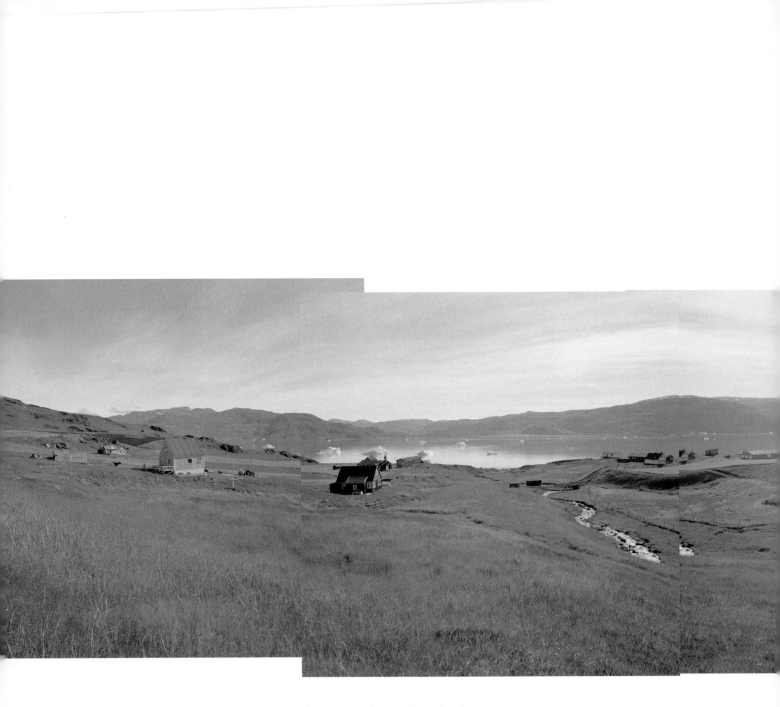

Brattahlid, the name Erik the Red gave his farm in southwest Greenland.

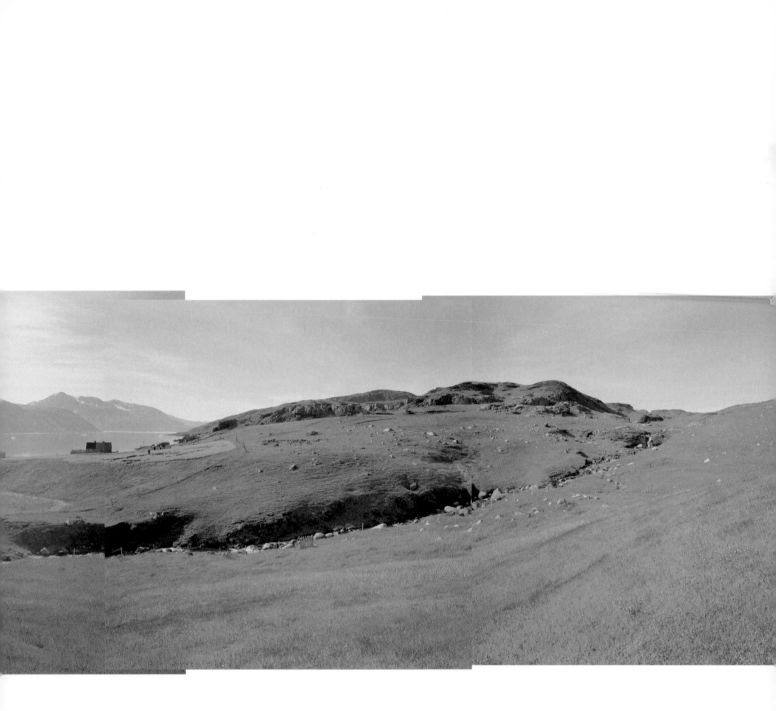

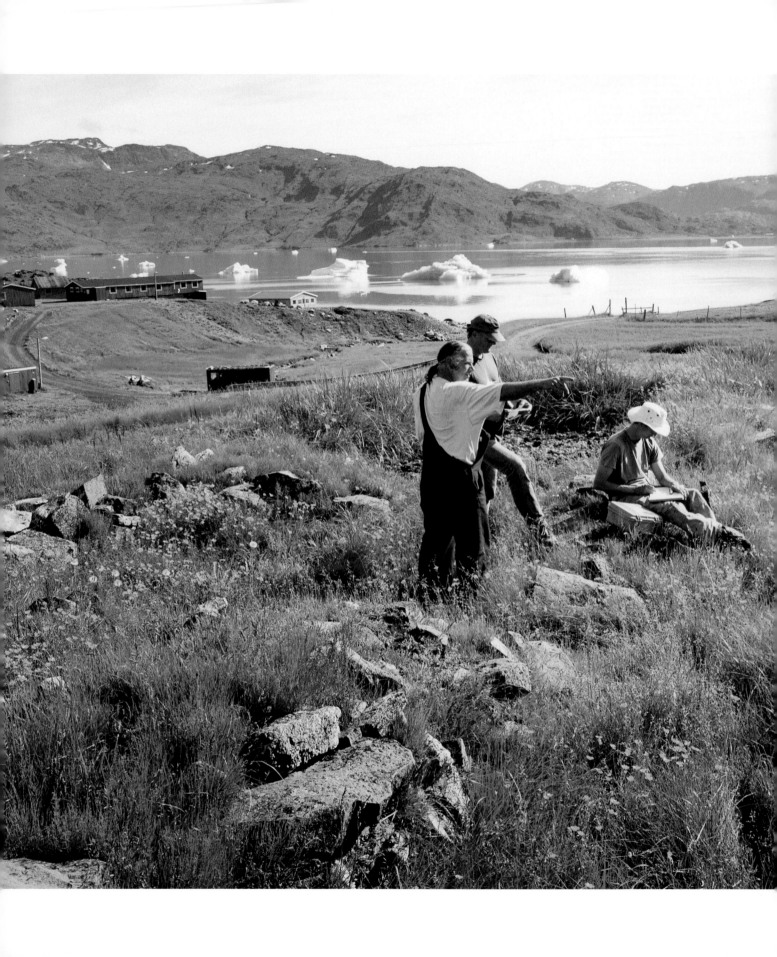

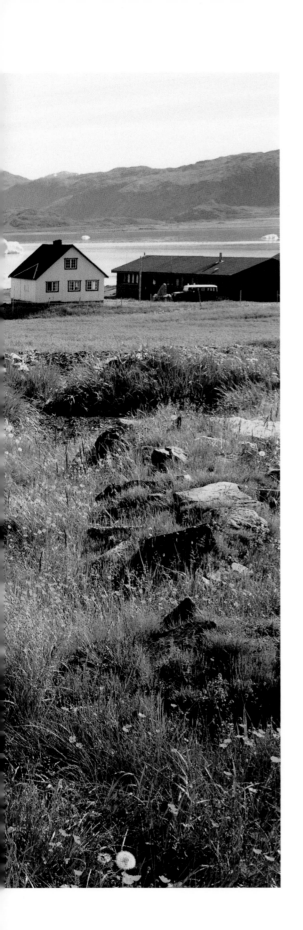

LEFT:

Trying to find Erik's (and his son Leif's) house site at Brattahlid.

ABOVE:

Sitting where Leif sat?

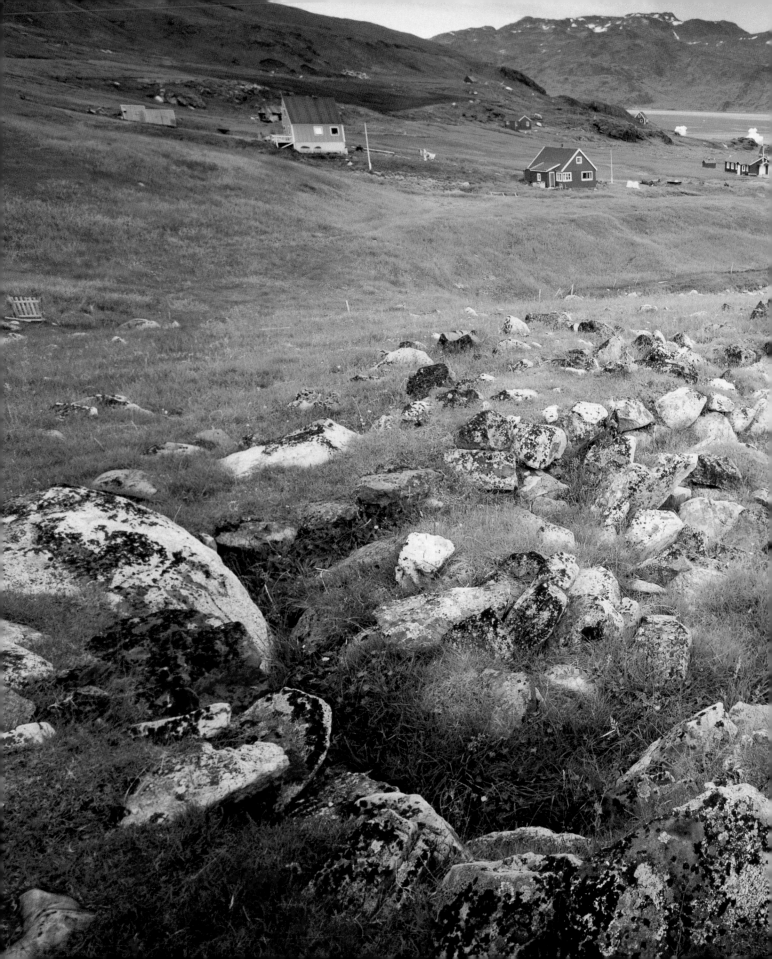

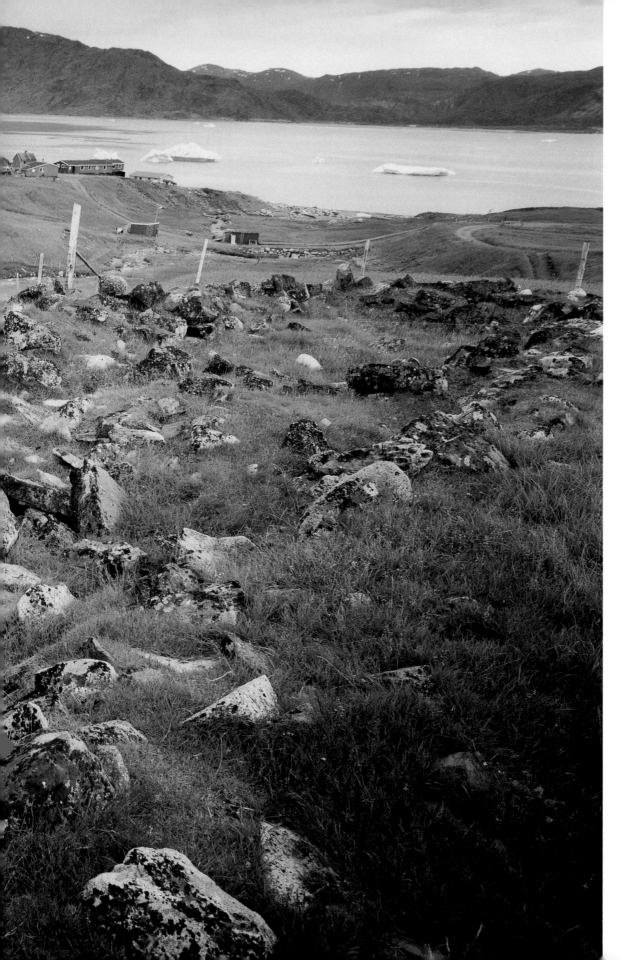

The Vikings lived here from 985 until the 1400s. It is not known why the colony ceased to exist.

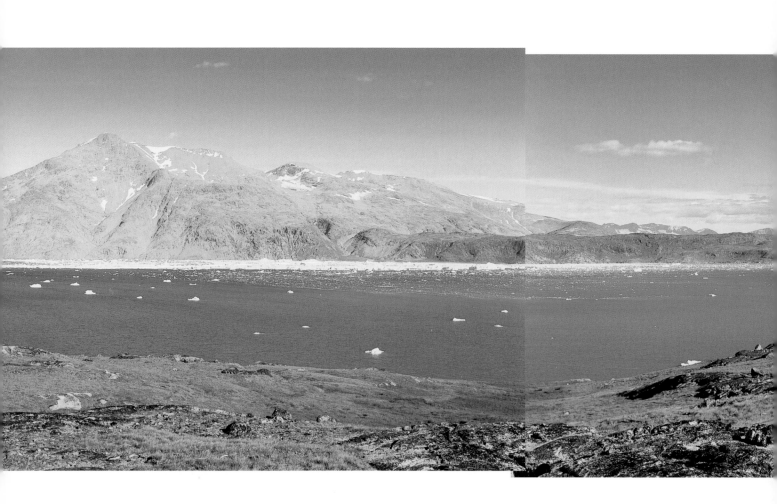

*Icebergs, growlers, and bergy bits
choke the narrow fjord.*

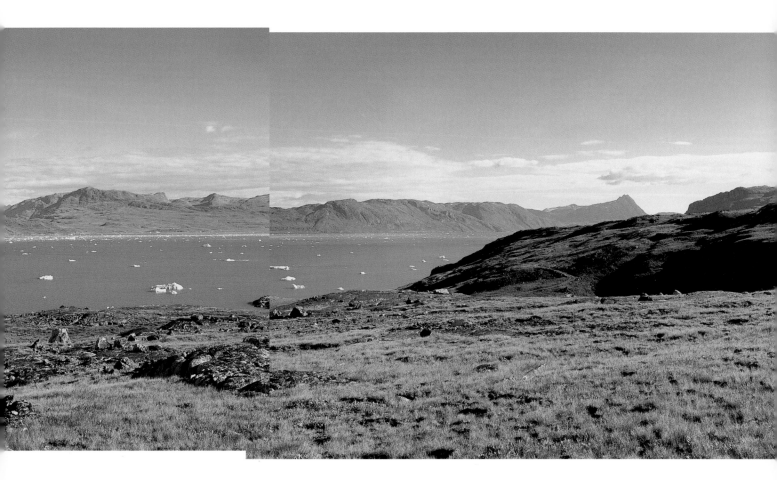

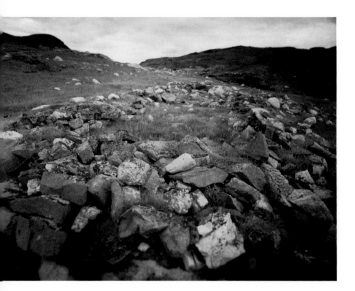

ABOVE:

The houses had stone foundations. The walls were made of sod and supported with driftwood timbers.

RIGHT:

We stand within an ancient tent ring, caribou antlers at our feet. So used to being together, the crew often remained in groups even while ashore.

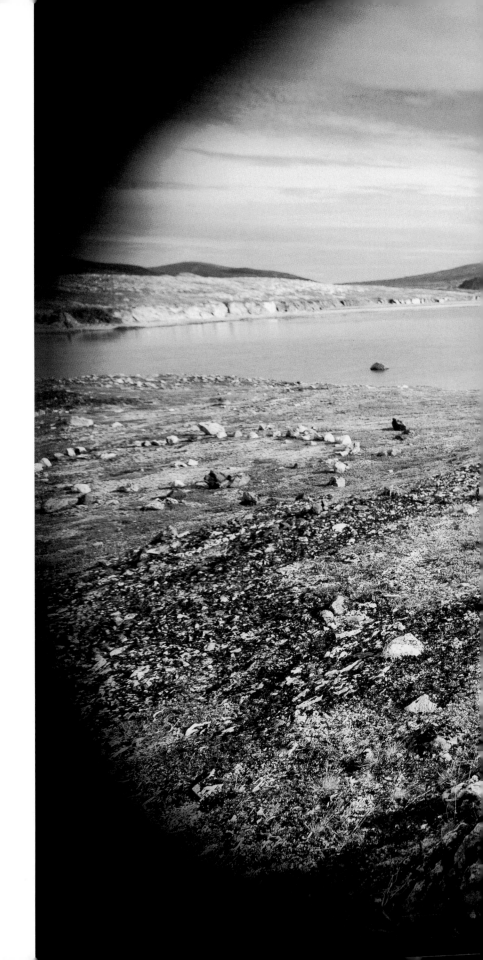

Inuit tent rings (left) are often found near good anchorages.

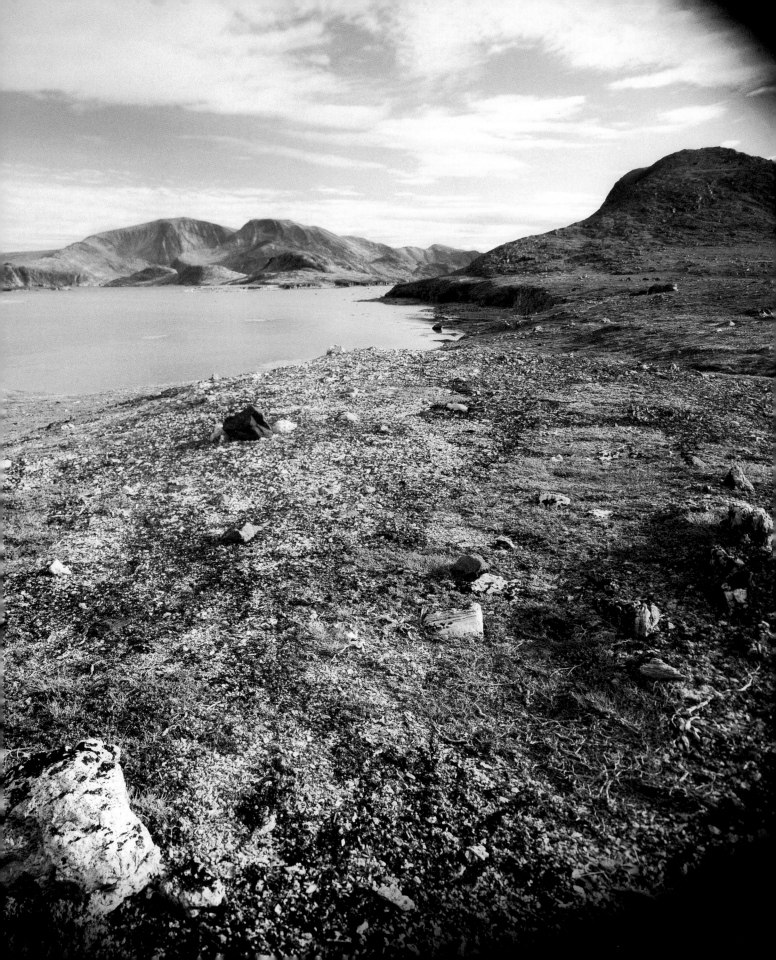

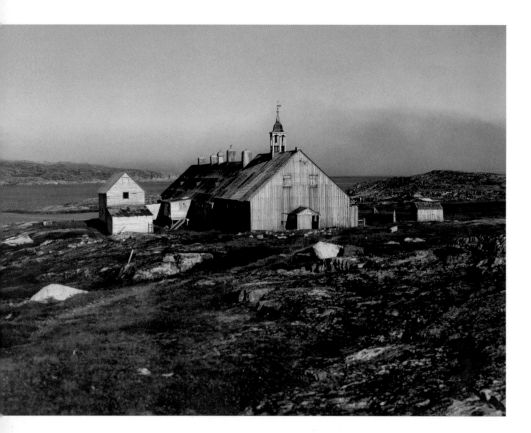

ABOVE:

The abandoned Moravian village of Hebron.

RIGHT:

*Labrador's northern coast was as useless to the Vikings
as it was mesmerizing to us. We wanted to linger and did—
thanks to a seasonal lack of northerly winds.*

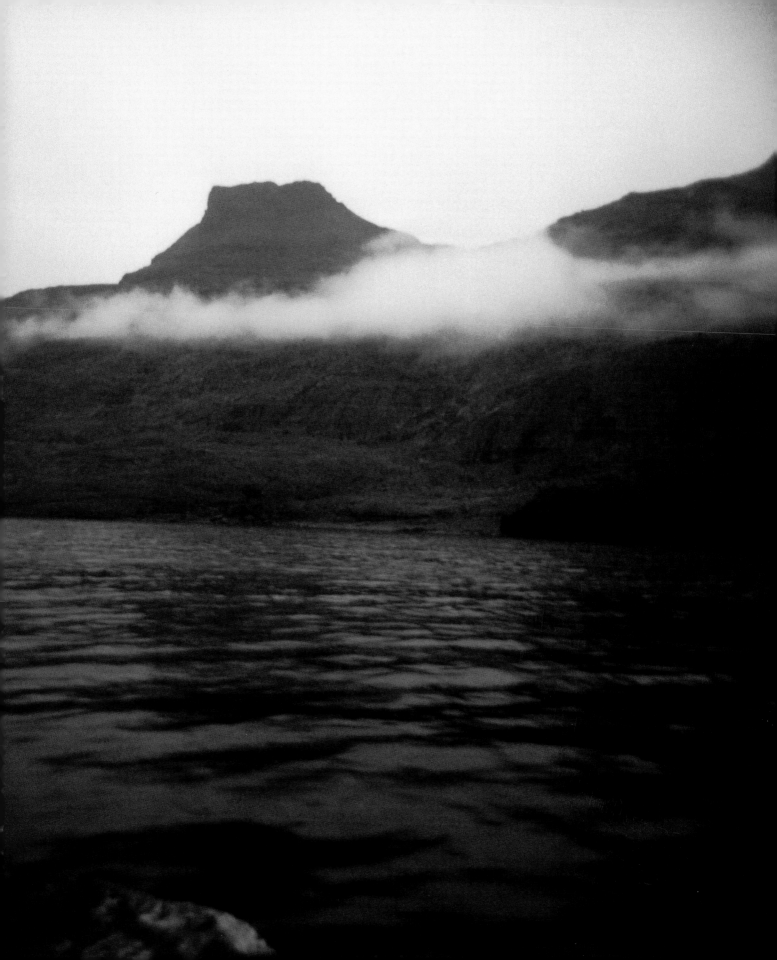

A Sinking Ship

By early August, we reach Nuuk, Greenland's capital, where we decide to shorten our route in Greenland and begin the crossing to Baffin Island. Within a week, we are one hundred fifty miles out into Davis Strait—the ice-choked body of water that separates Greenland from Baffin Island.

And that is where we are staying—at least for now. We are adrift in seven-foot seas, and our boat is falling apart.

I had expected this crossing to be the moment when we would come face-to-face with the Vikings and Nature. I knew it would be the defining moment of our voyage—and I am afraid it is.

Back in Maine, we had one small problem during sea trials: we couldn't turn the boat. Viking rudders hang off the starboard quarter and are called steerboards. In fact, "starboard" derived from *steerboard*. Evidently, the Vikings' ancestors had realized that by dipping an oar in the water near the stern and angling it a certain way, they could turn their boats (think of turning a canoe). The oar eventually progressed to a more elaborate design and became the steerboard. Sadly, it would be a few hundred more years before rudder development progressed to a stern mount, which, for many reasons that we had recently learned, is highly preferable to the quarter-mounted rudder. Anyway, we have a steerboard, and to make this type of rudder overcome its inherent restrictions, it has to be just the right size and shape, and its pivot point needs just the right balance. Ours didn't have these components, and we nearly collided with a few islands trying to turn *Snorri* during our sea trials. Short on time and knowledge, we built a huge replacement rudder designed to overcome the limiting factors of our original steerboard. It ran two feet deeper, and with it, affectionately dubbed the Cleopatra because Cleopatra's barge supposedly had a similarly shaped rudder, we could turn the boat.

The only problem, we have now realized, is that it is too big, and it has ripped out some of the internal framing in *Snorri*'s stern.

The crew isn't faring much better. One minute we're cruising off the wind at six or seven knots, and the next, we're foundering in six-foot seas. Rob Stevens, the boatbuilder, looks the worst. He is seasick and having a hard time focusing on repairing the boat. John Gardner, his stalwart, dark-haired assistant, is directing much of the work but is also feeling sick. At this point, there's not much they can do beyond keeping *Snorri* from collapsing in upon itself. A Coast Guard Canada ice-breaker, the *Pierre Radisson*, is steaming toward our position. It is going to tow us back to Nuuk, despite protestations that we can manage on our own.

Trevor Harris, our first mate, appears to be trying to keep everyone's spirits up, making jokes and apprising them of the *Radisson*'s whereabouts. Terry, the captain, is directing us in readying *Snorri* for the tow. We're mostly moving gear and adding chafe gear to a tow bridle, but it is difficult work lying abeam of these seas in a cold, strong breeze.

None of the crew is freaking out. Some appear angry that we are not going on, that we are allowing ourselves to be rescued. I especially notice that Homer Williams, our nineteen-year-old crew member, is scowling. I think he would rather die at sea than suffer being towed back to Nuuk. Others seem indifferent, almost as if they expected something like this to happen. They're carefully packing their bags for boarding the *Pierre Radisson*, not volunteering to stay on board during the tow back to Nuuk.

I am plain mad. Mad that this has happened. Mad that it is the right thing to allow the Canadians to tow us back to Nuuk and that we're not blustering forward. Mad that the people at the Viking Ship Museum in Roskilde, Denmark, were not more

forthcoming when we had rudder problems in Maine. Mad that our ignorance (mine, Terry's, and Rob's) kept us from understanding the little help they did offer.

Mostly, though, I'm mad about the way I've handled our time. If I had given us more time to work on the rudder, we would not have used the ridiculous Cleopatra rudder. If I had not been so impatient, I would have let us practice sailing in Maine for an entire summer. I know that sailing a knarr is tricky, that even the Vikings had their difficulties. When Erik the Red led the colonization of Greenland, twenty-five ships set sail with him in 985 from Iceland. Only fourteen completed the voyage. I know this, but it does me no good. We were not supposed to fail, especially not like this. Couldn't we at least have been bashed apart on a leeward shore or maybe even suffered a few weeks of starvation? In all my nightmares before setting sail, I never once dreamed we would be towed to safety when perhaps if we were a little braver or a little smarter, we could still complete our voyage.

I don't want to give up and have it end like this. We will be back. We will immerse ourselves in the past. We will make a better rudder.

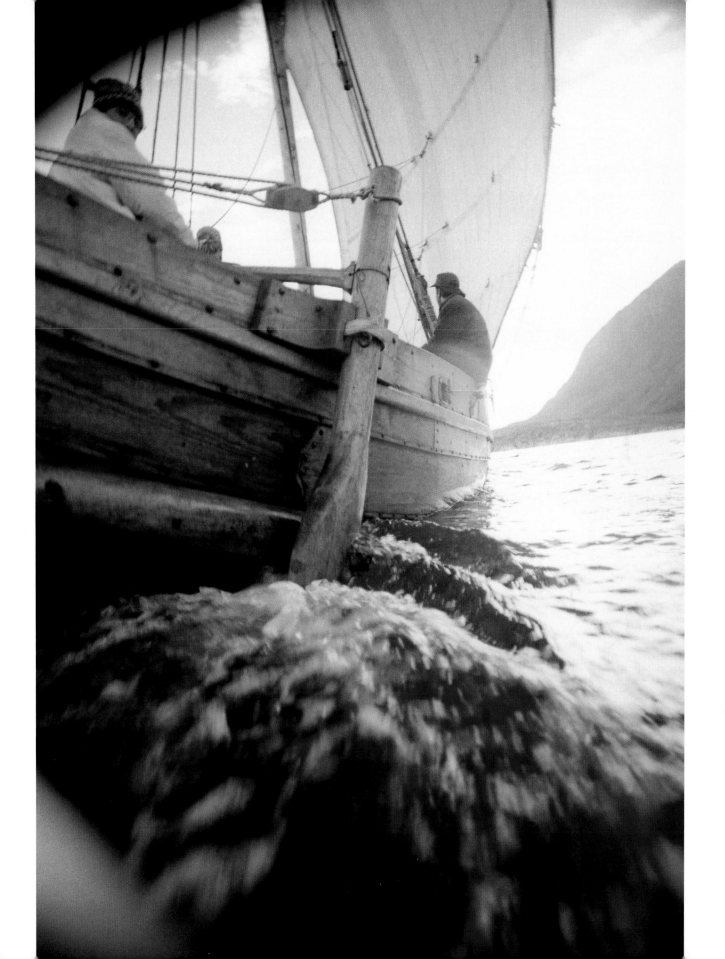

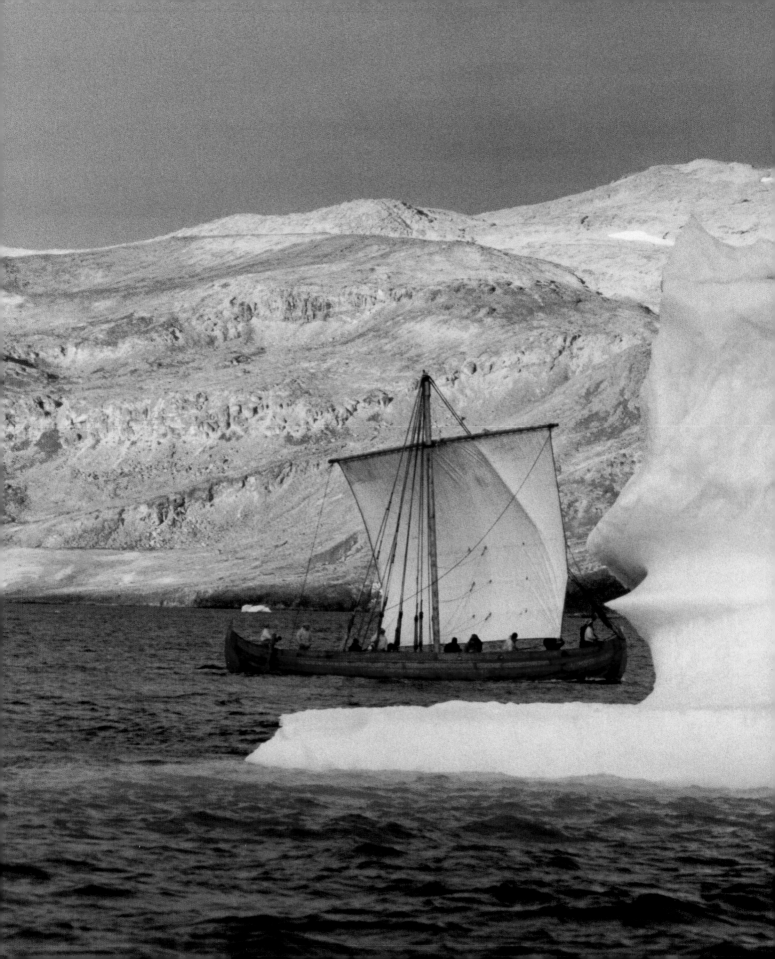

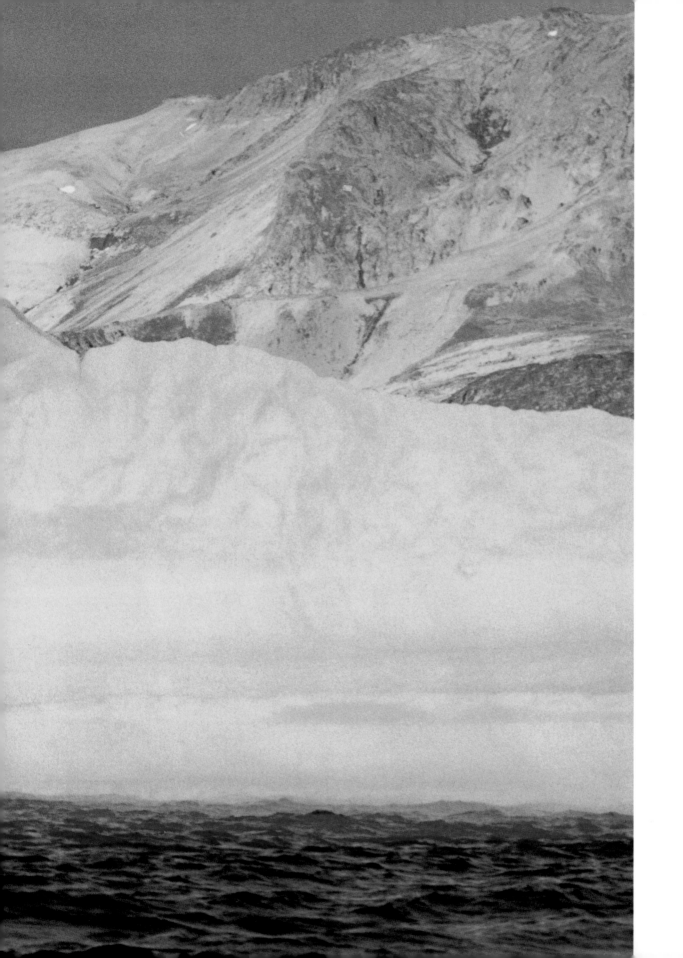

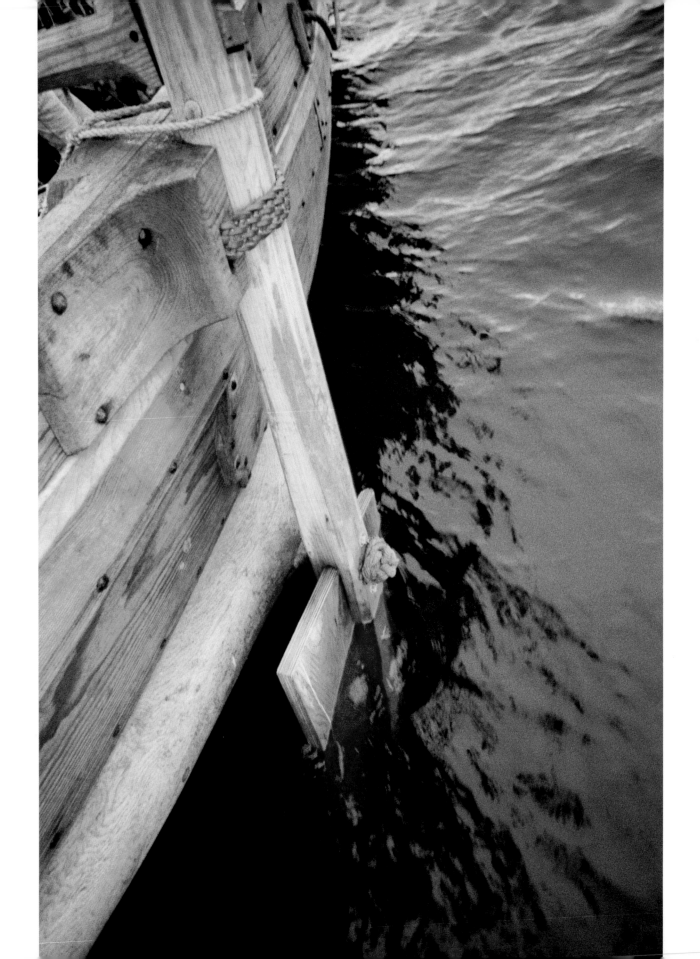

PREVIOUS:

Snorri *attempts to cross the Davis Strait.*

OPPOSITE:

Unlike the original rudder, this plywood mock-up could turn the boat.

RIGHT:

Some people collect baseball cards, Rob Stevens collects wood.

BELOW:

Rob builds a rudder that will help Snorri *turn—but at what cost?*

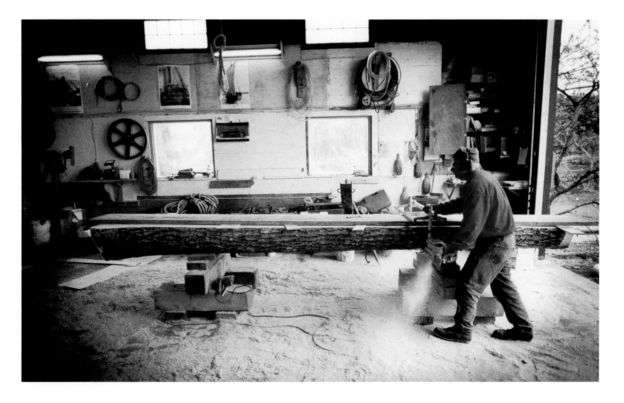

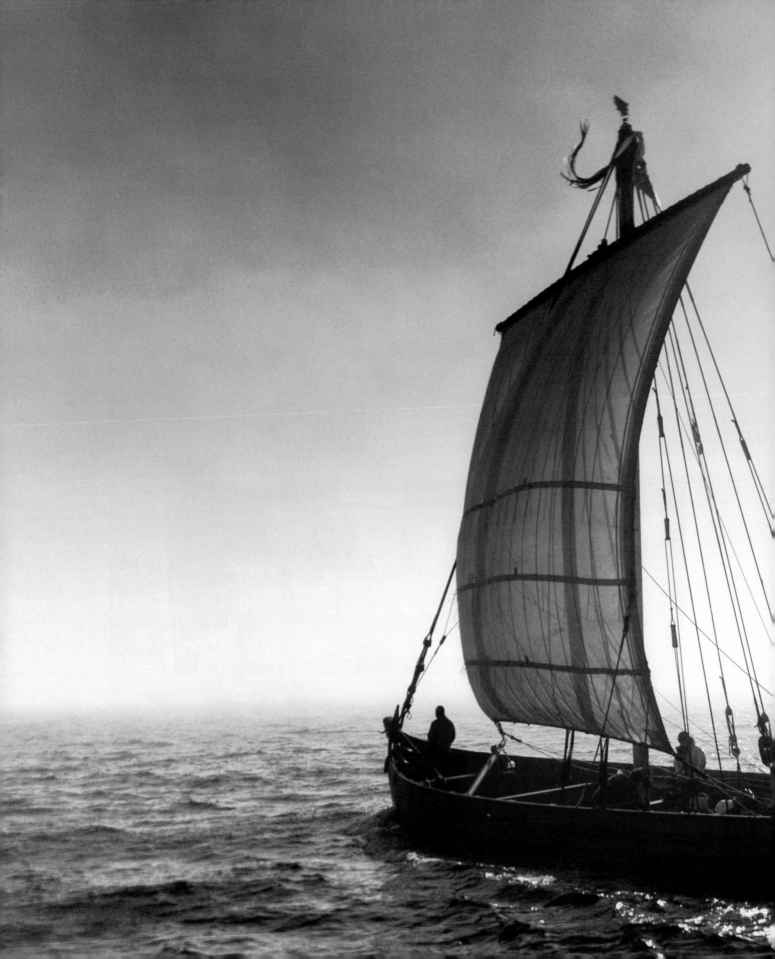

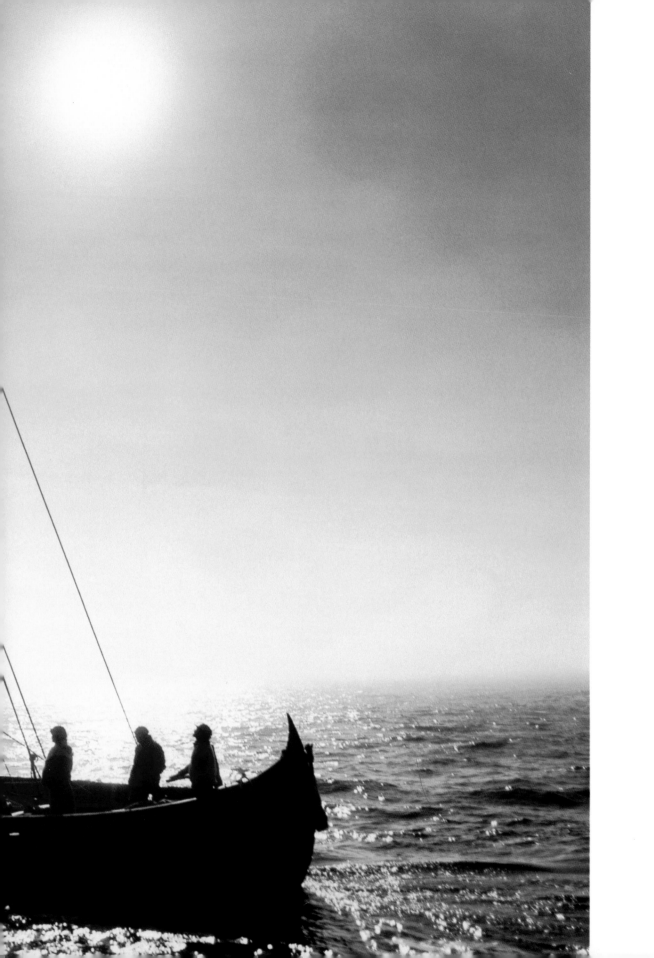

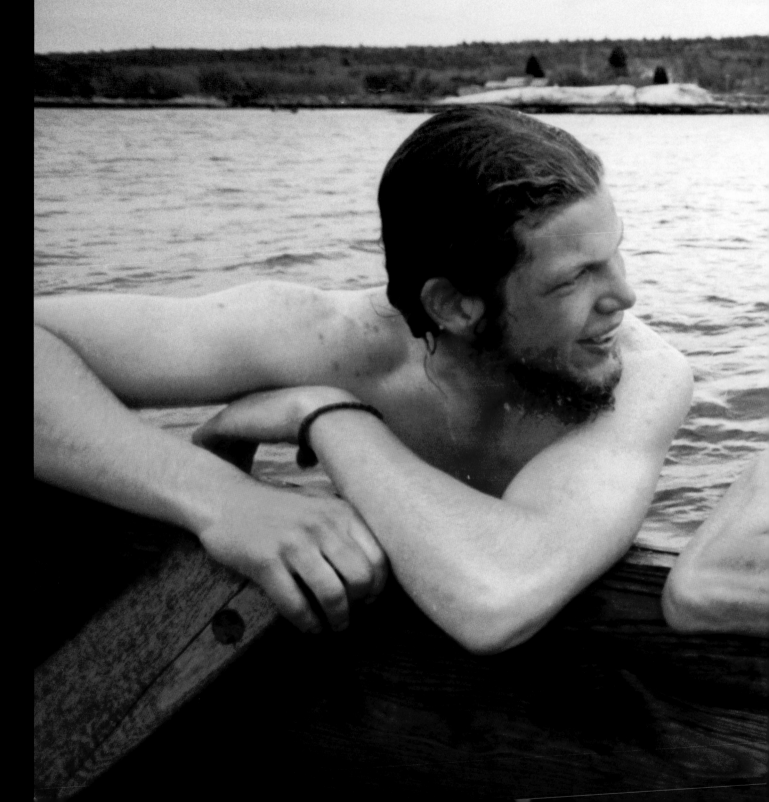

The New Vikings

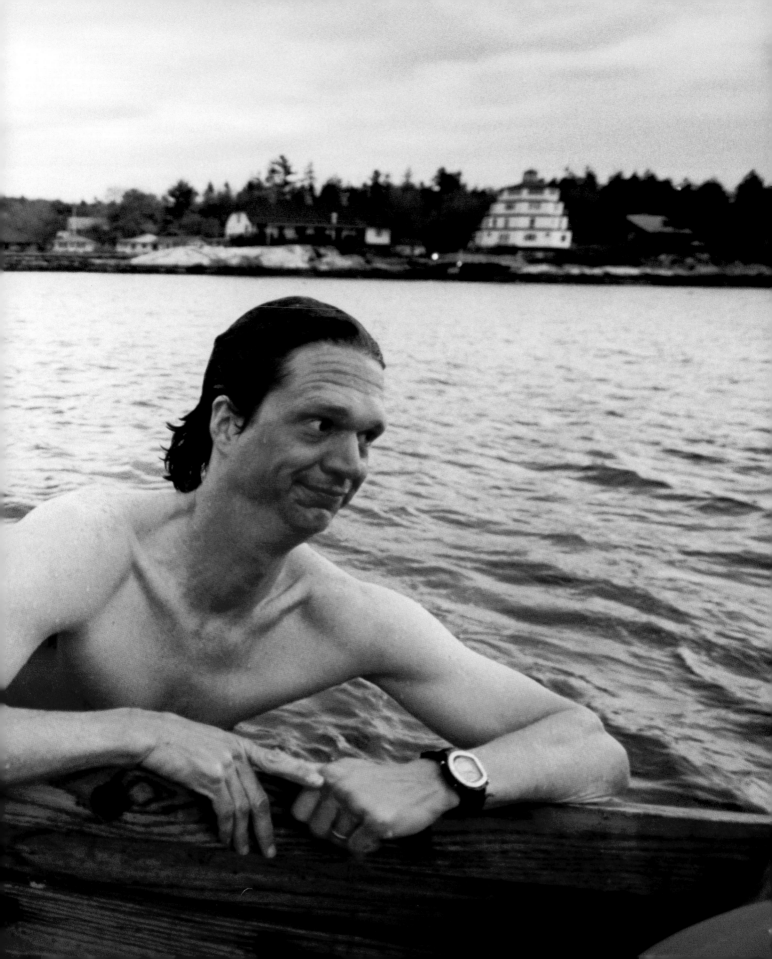

JOHN ABBOTT A skinny, freckled, long-haired wilderness instructor for the University of Vermont. He couldn't sail to save his life when this voyage began, but when things are toughest, John is right there, battling it out with the best of us. He is indispensable for his pluck alone.

JOB ON BOARD: General Crew, Cook.

DOUG CABOT A fit, modly dressed Boston drummer. He could be a poster boy for existentialism. He notices what the rest of us fail to see. Doug is also a fast learner. He has become a handy navigator and sailor while on *Snorri*.

JOB ON BOARD: General Crew, Cook.

JOHN GARDNER A bartender, surfer, and, most recently, wooden-boat builder. John is a charmer when he wants to be and a curmudgeon the rest of the time. He keeps *Snorri* neat and fit. John reserves expressing an opinion, but when he does, he is usually right.

JOB ON BOARD: Bosun, Assistant Ship's Carpenter.

ERIK LARSEN: SECOND YEAR A Danish Renaissance man.
Erik can quote Kierkegaard while he rows with one hand, cooks
with the other, and sews with his feet. He knows how to sail,
navigate, and make repairs. He has crewed other replicas before
but never with a bunch of uncouth Americans.
JOB ON BOARD: Watch Captain, Cook.

TERRY MOORE A lean, ascetic Outward Bound instructor and the best captain in the world for a Viking ship crewed by the likes of us. He is patient, ambivalent, and a good teacher. He would have preferred to have a more skilled crew but has coaxed us into shape.

JOB ON BOARD: Captain.

DEAN PLAGER A statistician by trade and adventurer by heart. Dean is an accomplished sailor and our oldest crew member at fifty-seven. He has crossed the Atlantic single-handed but defers to Terry on board *Snorri*.

JOB ON BOARD: General Crew, Communications.

ROB STEVENS The best damned wooden-boat builder alive. Rob could probably lift all twenty-five tons of *Snorri* (ballasted) with his back, yet he was also once heard muttering of the crew, "This is a swell bunch of guys." His running commentary and inappropriate asides keep us laughing. He gets seasick in two-foot swells but manages to hold his own when duty calls.

JOB ON BOARD: Ship's Carpenter.

HOMER WILLIAMS Teenage furniture maker.
Homer has been sailing practically since he was a
toddler, and at nineteen, he's our youngest crew mem-
ber. Even at his young age, he has a story to fit every
occasion. He is a natural sailor and thinks nothing of
sailing an open boat in twenty-five-foot seas.
JOB ON BOARD: General Crew.

HODDING CARTER A weak, temperamental writer. I didn't know a thing about sailing before the journey began, and now think I know everything. I have become an adequate sailor and try to massage everyone's egos—when I'm not inflaming them. I am moody and impatient. I keep a hidden stash of chocolate bars that helps keep me sane.

JOB ON BOARD: Trip Leader, Cook.

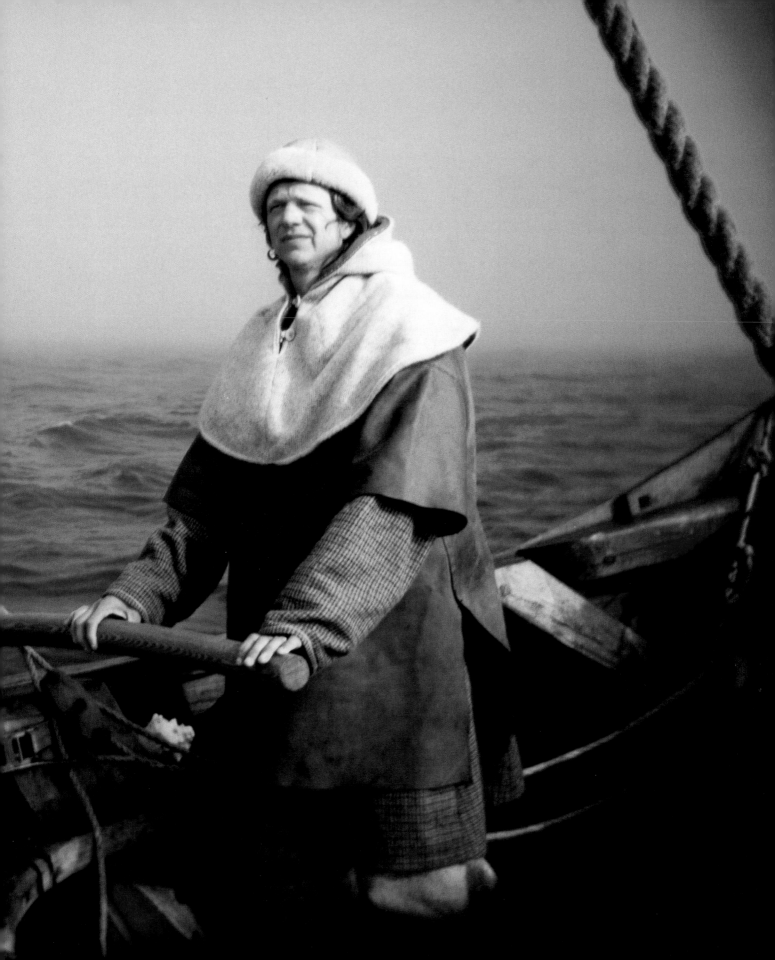

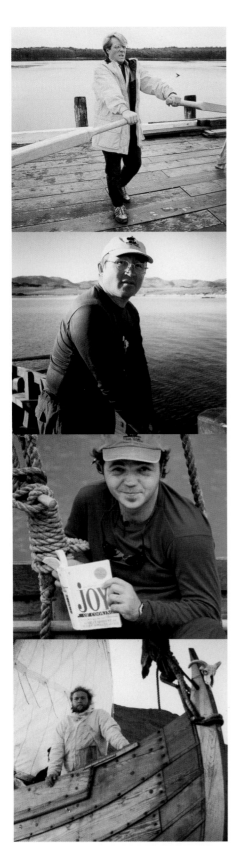

TREVOR HARRIS: FIRST YEAR

Outward Bound instructor and friend of the captain's. He puts his back into any difficult task that arises but often frets about our safety. If things are falling apart— say, a Viking ship—he's a great person to have around.
JOB ON BOARD: First Mate.

ELIAS LARSEN: FIRST YEAR

Our only Greenland crew member, Elias has been a local judge, teacher, carpenter, and fisherman. His sense of humor often keeps us from taking ourselves too seriously. Elias intuitively knows how to sail and often improves the way we work and live on board.
JOB ON BOARD: General Crew.

JAN CALAMITA: FIRST YEAR

Jan can make great risotto, even when sailing windward offshore in a rainstorm, huddled over an exposed, temperamental kerosene stove. He is a lawyer by profession and only a budding outdoorsman. Yet he is invariably the only one who snags an errant line just before it's too late as we're bearing down on a looming iceberg.
JOB ON BOARD: Cook.

ANDY MARSHALL: FIRST YEAR

Our resident salty dog. Looks the part and plays a sweet guitar. Most amazing skill, besides knots and splicing: can sleep while standing.

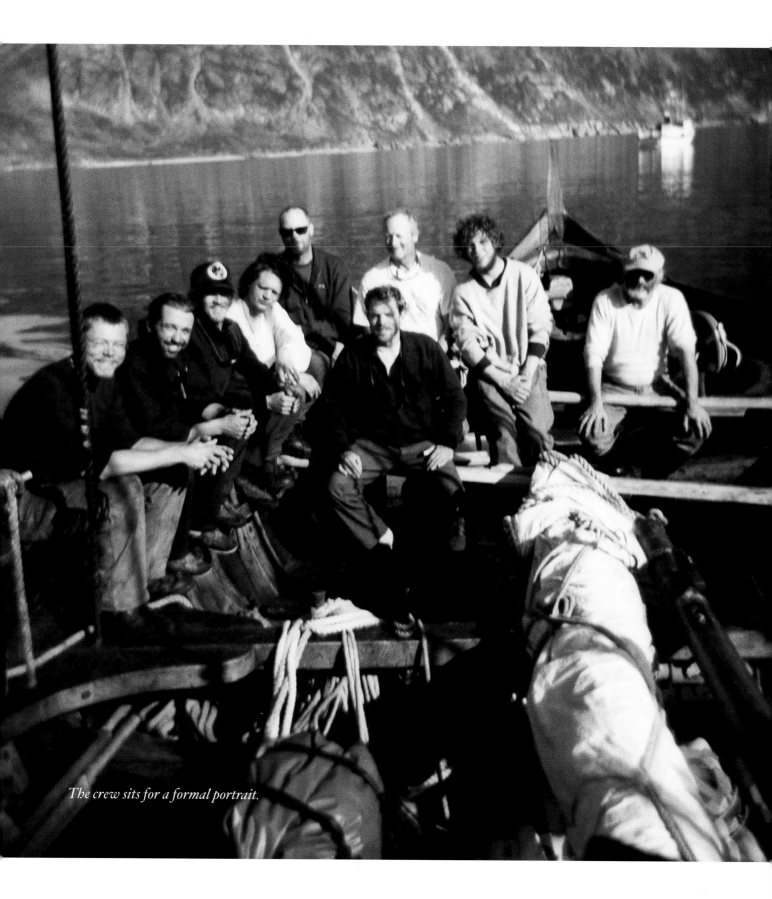

The crew sits for a formal portrait.

A Return to the Sea

A fitful, evolving year has passed, and here we are, waiting on board *Snorri*, again. We have made it to Baffin Island. Sneaked by nine polar bears. Proven that Viking clothes are as good as, or even better than, modern outfits—at least when sailing a knarr; my two-layered wool outfit, leather tunic, and heavy wool cape have served me well for two months now. In fact, I still have all my fingers and toes.

We've even reached northern Labrador, but it does not appear we will make it any farther.

You know things are bad when the neighboring iceberg makes more headway than you. Certainly, icebergs are a divine creation. They represent both the sublime beauty and destructive power of nature. They travel for thousands of miles before succumbing to ablation—the erosion of an iceberg by melting, water action, and evaporation. The tallest ones calved in western Greenland rise two hundred feet above the ocean's surface and stretch out for hundreds of feet beneath. When they roll and thunder, it sounds as if the earth itself is collapsing. If we were so unlucky as to be next to an iceberg when it rolled, we would be destroyed. Yet, they look stately, as if they could survive for eons. You even want to break out an ice ax and start climbing.

But you don't expect one to beat you in a sailing race.

Technically speaking, the particular iceberg that I'm watching pass us right now is not sailing. Our Canadian Coast Guard manual, *Ice Navigation in Canadian Waters,* explains that "the iceberg moves in a direction that is primarily the result of current because of its large keel area." Since there is no wind, I would have to agree.

The wind has been blowing either in our faces or not at all for two weeks now. We have been sailing into the wind and getting nowhere or rowing when the wind lets

up. The iceberg I'm mad at has been serenely gliding down the Labrador coast, staying just a few miles ahead of us. One day we even passed it, but by the next morning it was a few miles ahead. Last night, taking our cue from its progress, we tossed out our sea anchor to ride the same current. We made less than one mile.

Nearly all the icebergs we have seen originated in northwestern Greenland. Of the ten thousand icebergs that can be found in northern waters in any given year, only one hundred fifty of them are calved from Canadian glaciers. So, many of these icebergs have traveled even farther than we have this summer.

How disturbing.

More disturbing is that today is August 21. The summer is ending and we still have six hundred miles to go. It has taken us nearly two months to go a little more than that. This preys on our minds, especially since we will not be calling for help, as we did last year, unless this boat is sinking beneath us. We will keep going.

Will we have enough food? Can we get more kerosene for our two-burner stove? Will the fall storms start before we get to Newfoundland, making headway nearly impossible? Will some of us come to blows?

I picked most of this crew more for their sense of humor and willingness to try something completely new than for anything else. Most of them are not sailors, which has been a burden for Terry, the captain, but they have learned a tremendous amount. Will they survive this, though?

Last year, we had to wait for days at a time, and earlier this summer, we waited more than two weeks for the right wind to take us across to Baffin Island. Those were trying times, but the crew, instead of complaining, engaged themselves in woodworking, carving reindeer antlers, and maintaining boat gear. Now the problem is that we

thought we were almost done. Terry had pulled out a chart showing how far we had to go and we felt the end was near. After all, we had crossed nearly one hundred miles from Baffin Island's Hall Peninsula to False Bay in northern Labrador in one day. Ha.

Leif Eriksson and the Vikings who both preceded and followed him supposedly sailed this entire route in nine days. To do this they would had to have had a south wind in Greenland for exactly two and a half days, followed within an hour or so by an east wind for one and a half days, which would then have immediately turned into a north wind lasting five days. The wind would have to have been blowing strong enough, twenty knots or greater, the entire time to allow the knarr to average nearly ten knots. Leif and his men could have stepped on shore for only about two minutes on Baffin and Labrador. This is ridiculous, of course.

Some authorities argue that the nine days merely means nine sailing days and that it is a measurement that equals 124 miles. If that were the case and Leif followed the route we are taking, then we have just about reached Vinland, but that does not seem to be the case by any stretch of the imagination. We're staring at a desolate seashore.

These confusing, contradictory theories should be depressing, but instead they are slightly uplifting. We know for a fact that the Vikings made it to L'Anse aux Meadows, our final destination, and that they arrived there from Greenland. We also know that the voyages to Vinland have always been recounted and recited as if they were simple nine-day jaunts, and from this, many historians have assumed that the Vikings were traveling back and forth all summer long.

With our waiting and our excruciatingly slow pace, however, we have shown that this was surely not the case, that these voyages were each probably a season long. Our discovery may not mean much, but it makes the waiting a bit more bearable.

Well, not really, but thinking about this is much better than worrying over our rations or watching a waterbug speed past our meager wake.

Another week painfully passes. The winds. when existent, have remained unkind, blowing from the south. We are all tired and worn from rowing and worrying. Yet, we decide to sail.

We could sit here as usual and wait for the wind to die down and then row eight, ten, or twelve miles. Plod our way south, sulking that the conditions are not better, cursing Torngat, the local god who controls all things. Instead, we choose to head out to sea. We'll sail ten miles offshore and then ten miles back. We'll only make four miles good, but it will not matter. We'll be sailing.

We'll man the *beitiáss* — the wooden spar that holds the sail down and forward and allows us to point windward.

We'll stand bow watch.

We'll don our ocean-class nylon sailing suits (or in my case, an extra layer of wool) but stamp our feet because the subarctic wind still finds a way to make us cold.

We'll sweat the halyard, huffing mightily to raise the yard those last few feet.

We'll harden sheets and set our braces.

We'll wander out to sea—beating our heads against the uncaring tide—simply because we can.

We'll awake a bit more tired tomorrow, perhaps, but we'll know we did not give up.

This is what the Vikings lived for.

To borrow the words of Doug Cabot, an eloquent member of the crew, *this is the kind of sailing I signed up for.*

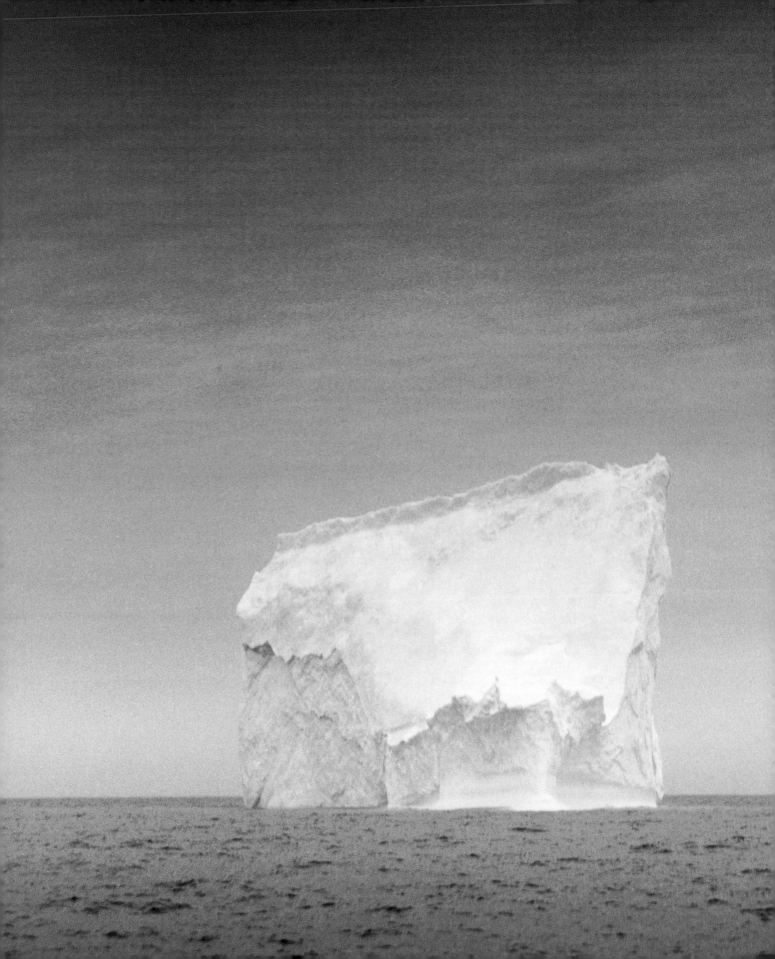

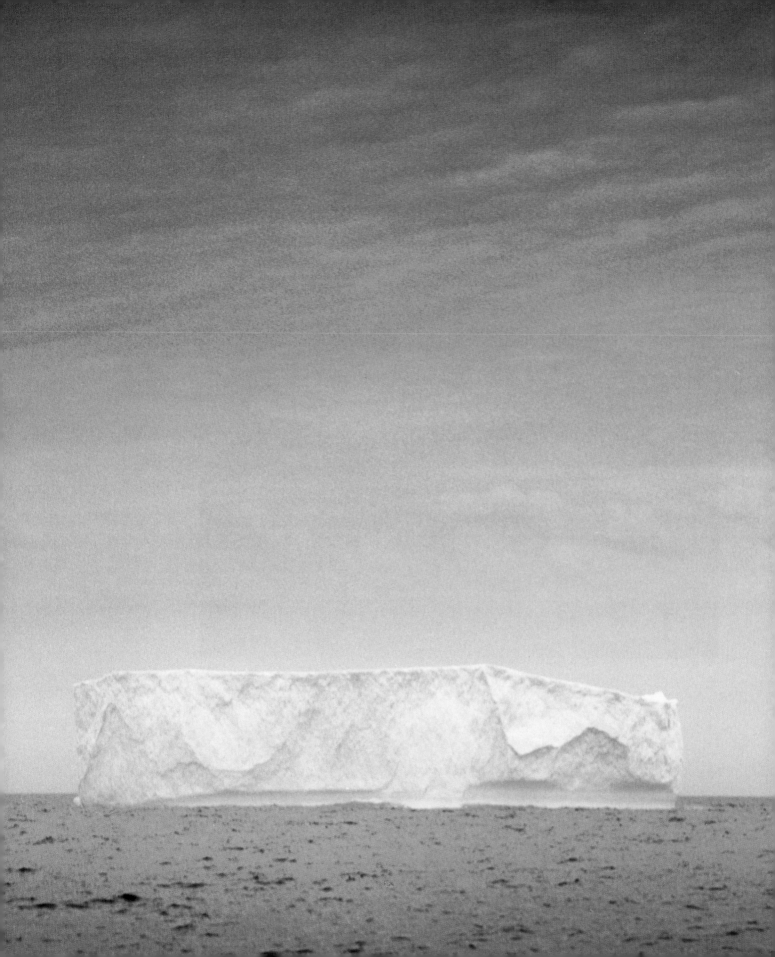

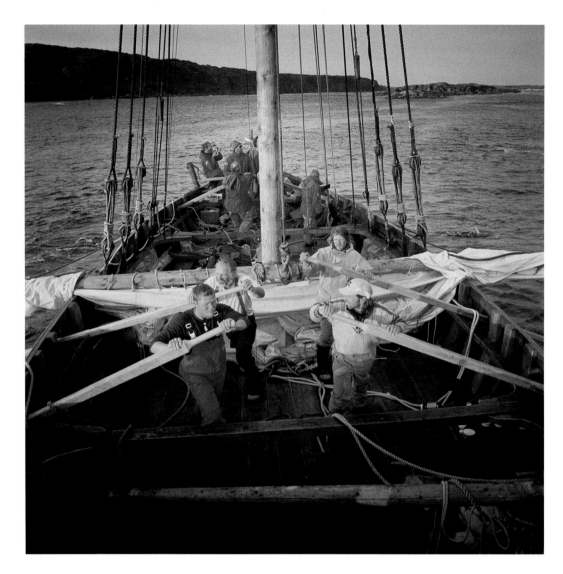

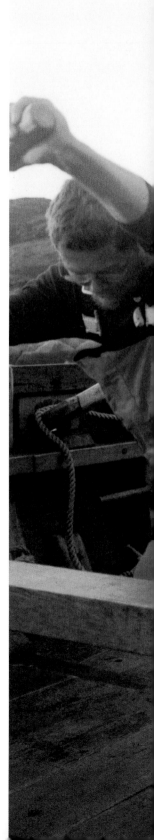

ABOVE:

*We rowed six at a time when fighting a wind
or current but still only averaged a knot at best.*

RIGHT:

*A Viking longship was rowed from a seated position.
A knarr—thanks to its eighteen-foot oars and particular
oar port placement—had to be rowed while standing.*

PREVIOUS:

*The August sun gets hot enough on this day to create
an ice-melt waterfall on the side of this giant berg (left).*

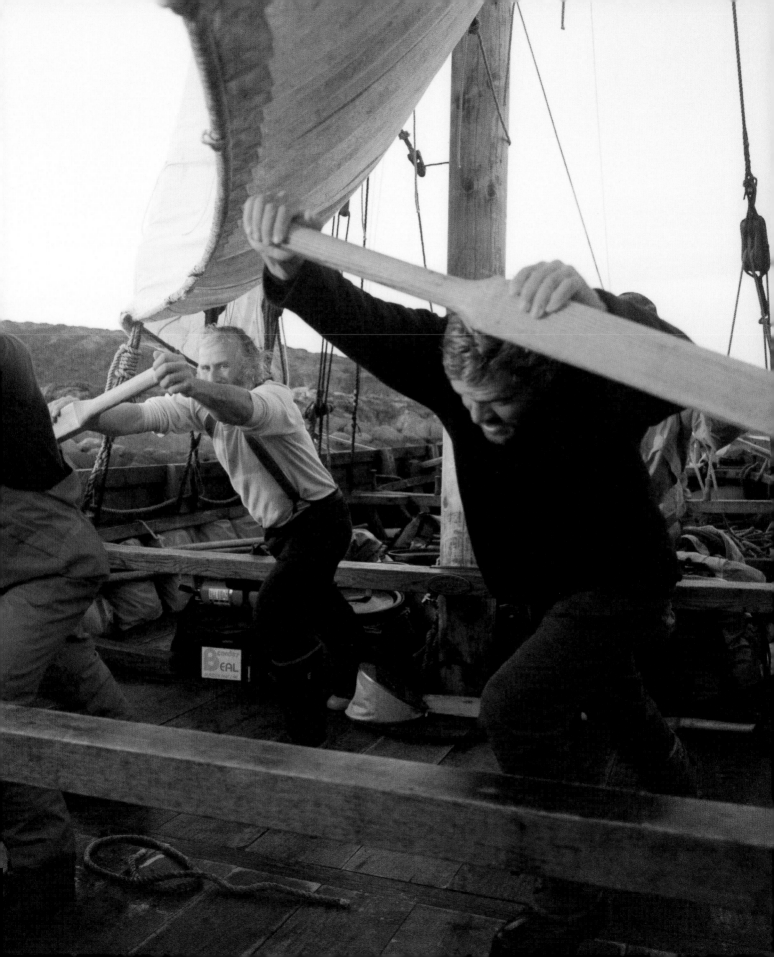

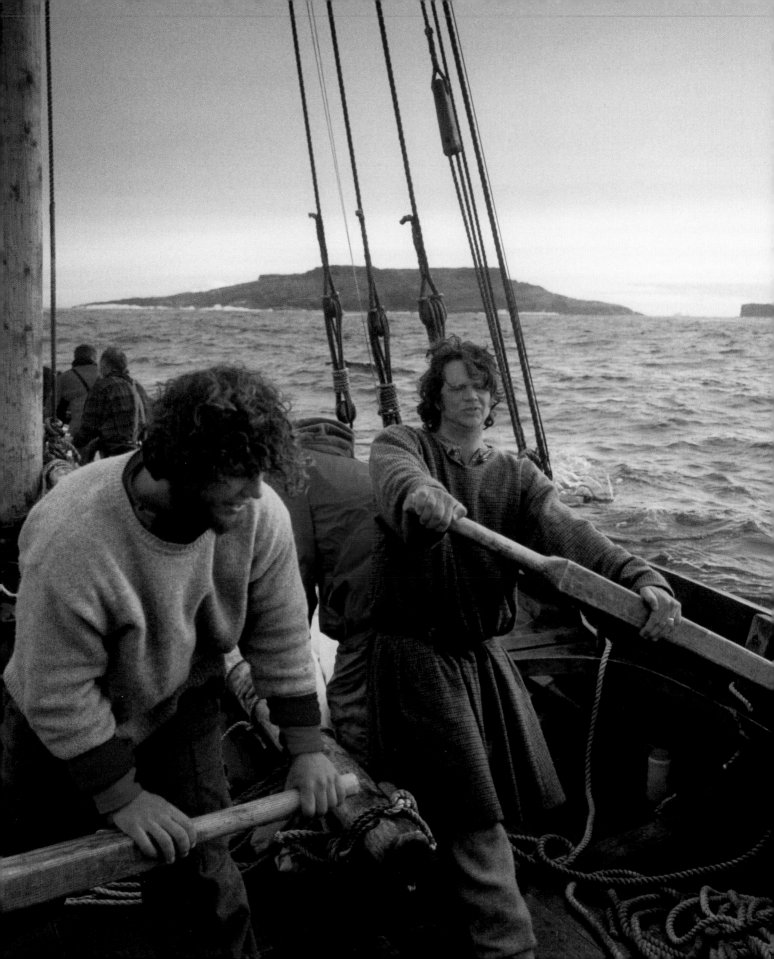

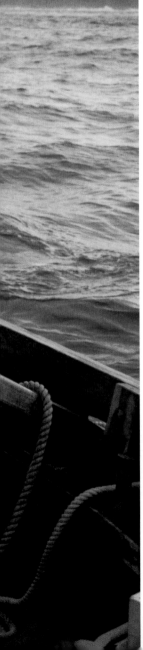

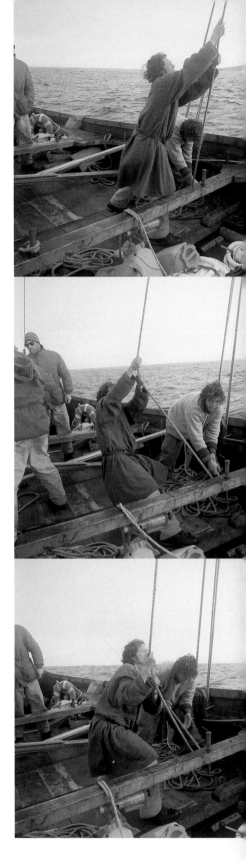

LEFT:

Homer (left) returned with shorter hair. Hodding came dressed like a Viking. Yet we still couldn't row in unison.

TOP RIGHT:

Raising the yard was a two-person job.

CENTER RIGHT:

One person "sweated" the halyard, pulling the line down, while the other tailed, keeping the line taut.

BOTTOM RIGHT:

By the time the yard reached its optimal height, the "sweater" was exhausted—feeling as if he'd just run an eight-hundred at sprint pace.

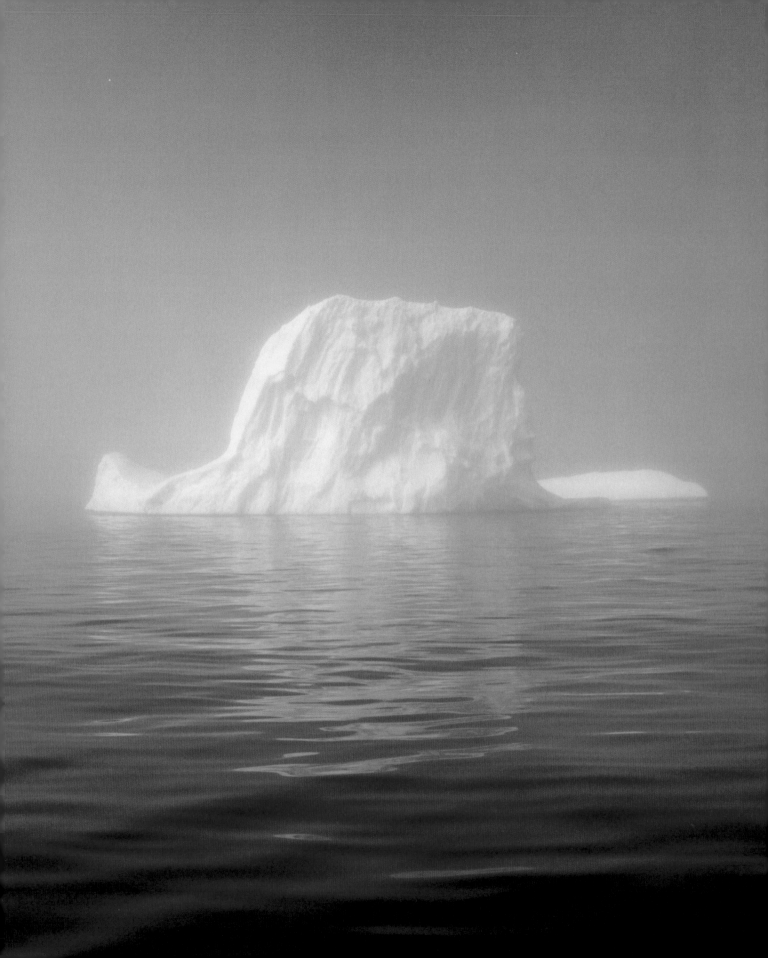

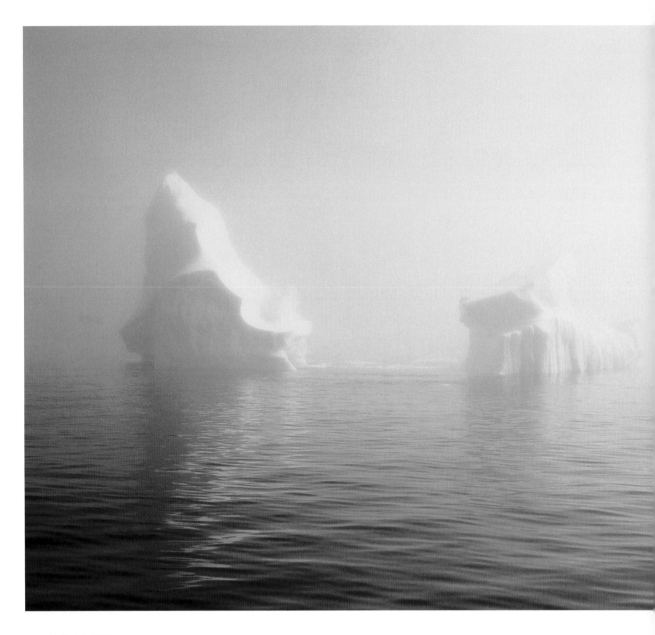

Icebergs are not stable. They turn, tilt, roll,
and break off without any notice. If we
were ever to hit a berg, our trip would be
over. It would be like hitting a mountain.

OVERLEAF:

Snorri *at anchor. The Vikings used their sail to
make their nightly shelter; we used a canvas tarp.*

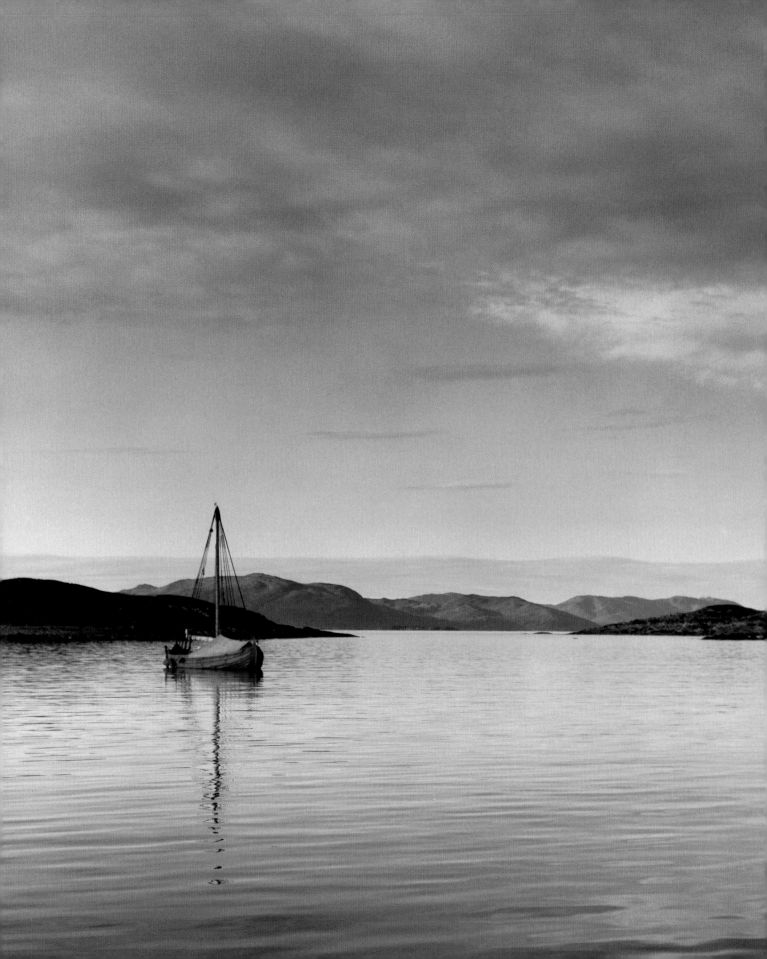

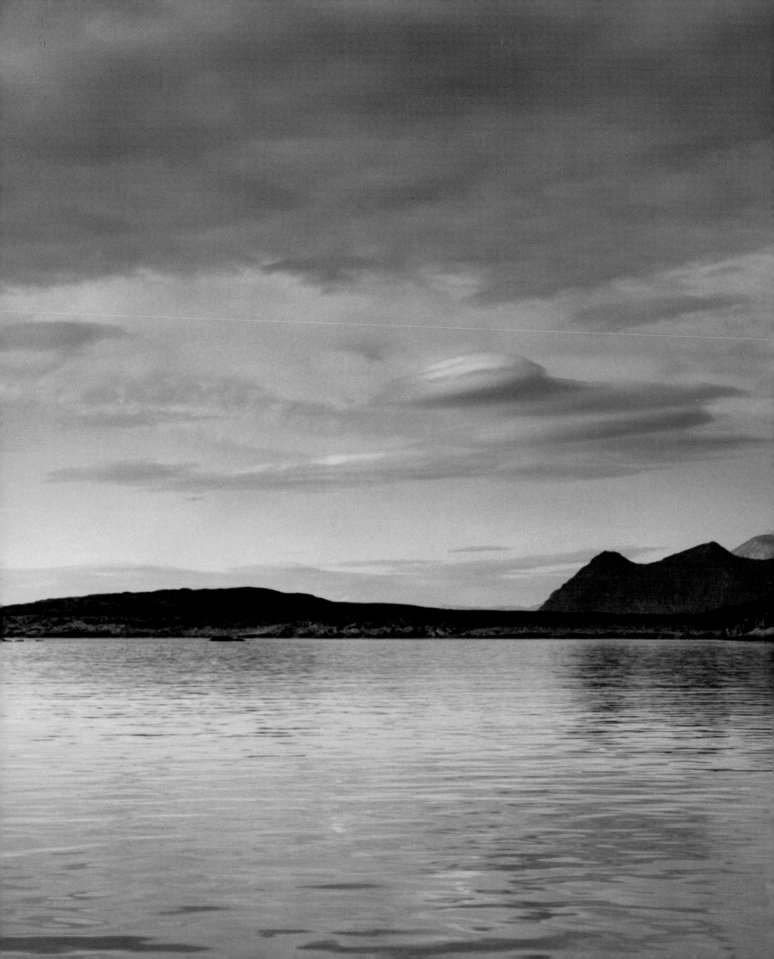

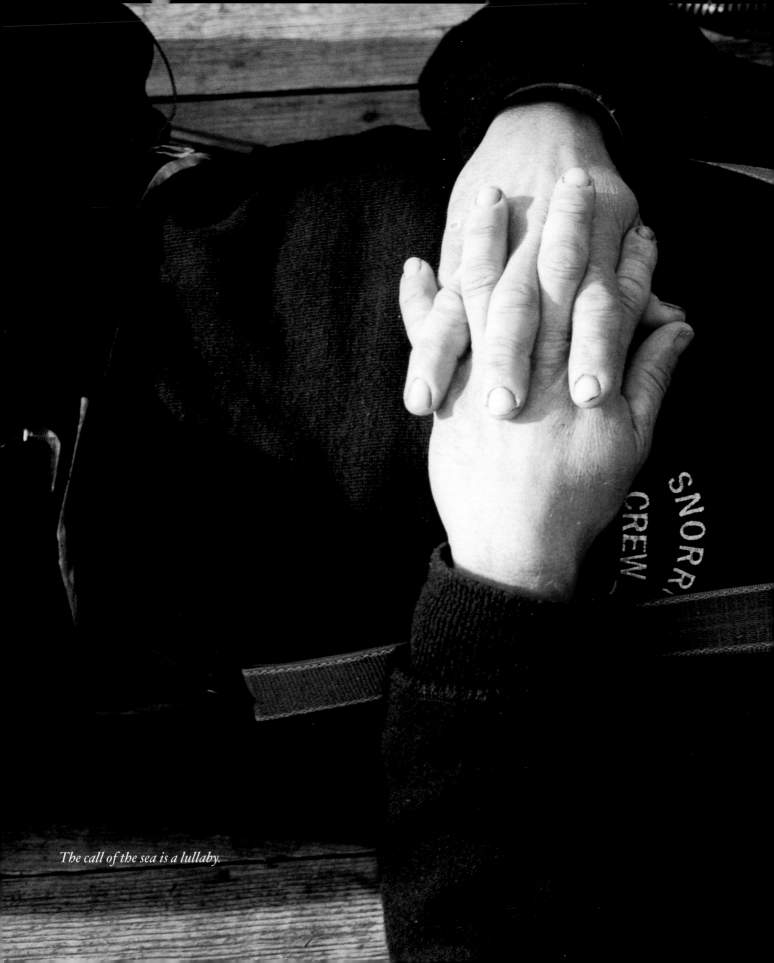

The call of the sea is a lullaby.

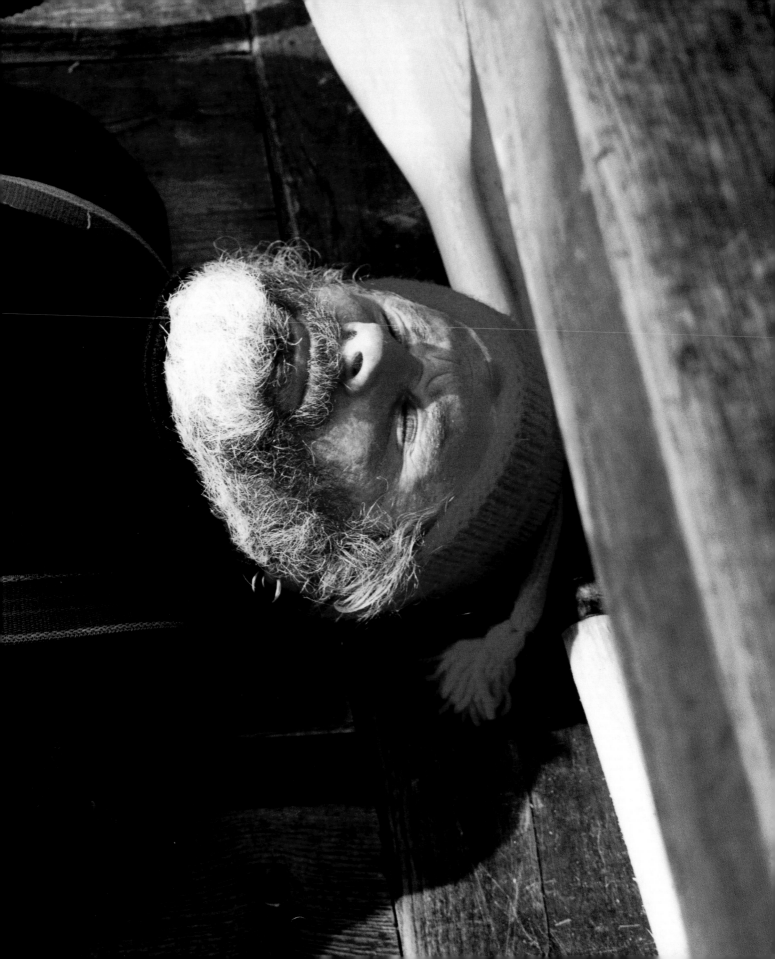

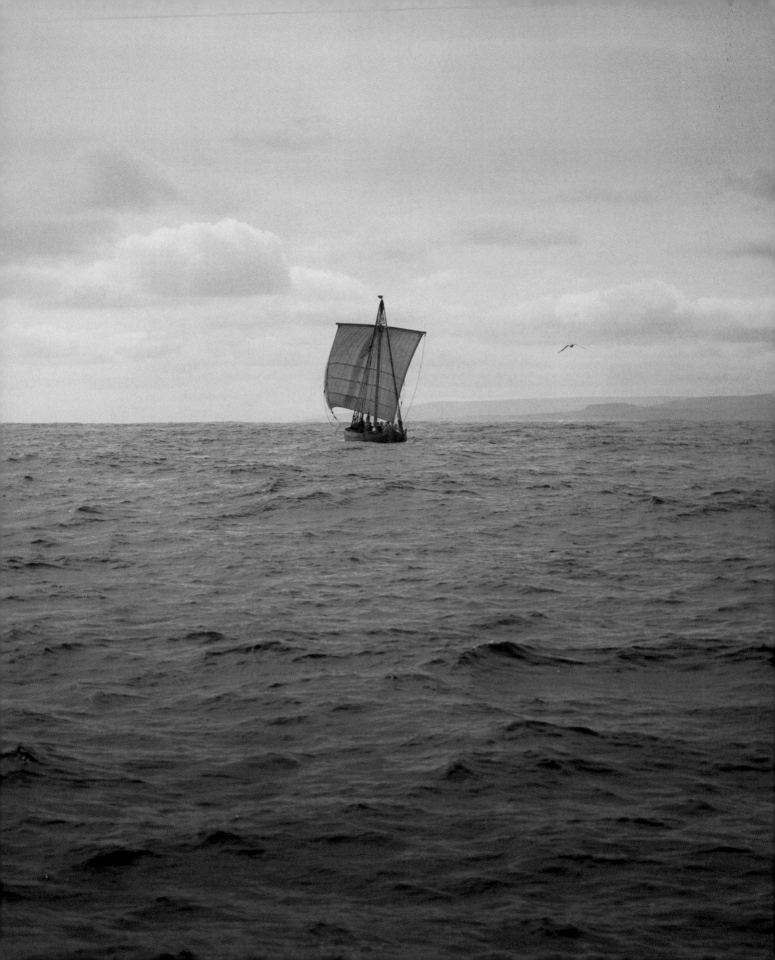

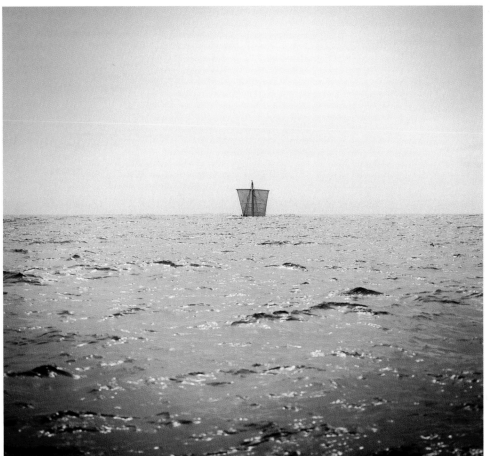

OPPOSITE:
Snorri *skipped over the tops of waves just as the lore predicted she would.*

RIGHT:
. . . except when the swells were nearly as tall as Snorri's mast.

*Hodding's wool Viking attire became
as comfortable as jeans and a T-shirt.*

Vinland Bound

Leif Eriksson was not impressed when he and his men landed at Markland, the land of trees. The *Greenlanders Saga* tells us that Leif said, "This land shall be given a name in accordance with its nature, and be called Markland," and then quickly returned to his ship.

Odd, this rushed behavior, since the land was covered with forests and possessed a gently sloping beach. Leif had spent an entire childhood and young adulthood in a land where the average tree was no taller than he. One of the very reasons he set sail was probably to see these trees.

I have never really understood how or why he would so readily leave Markland—until now.

I am looking at Markland for the first time through binoculars. I've wanted to arrive there by knarr for four years now; I've even dreamed about arriving there. It is one of the major touchstones for this voyage. "If I could just step foot where Leif went ashore . . ." I used to wonder. Beach *Snorri* on the gently sloping bank, jump overboard, and dig my bare feet deep into the wondrous sand (later Viking travelers dubbed this beach the Wonder Strands). I knew that in so doing we would get a little closer to the past by shared experience and genuine proximity.

"Those trees look so huge," I say aloud to my crewmate John Abbott standing beside me. We anchored beside a small grove of stubbly spruces a few days back, but they did not compare to these towering beauties. Homer, our youngest crew member, hurried ashore and spent the day scratching his back against the trees. I can't imagine what he is going to do with these. We haven't seen a forest for three months.

Terry, the captain, works his way toward me. "Hodding," he says, firmly, "I don't think we should go ashore . . . This wind . . ." We were probably making eight or nine knots at that moment, equaling *Snorri*'s theoretical hull speed.

For a whole second, I cannot believe he is being such a killjoy. "But, but, but . . ." my mind screams out. The next second, though, I hear myself saying, "I know. I agree. We've got to take it when we can."

Terry and the ocean itself have taught me more than a bit about sailing as the Vikings, and countless others throughout history, knew it. When sailing like a Viking, one learns a form of selflessness that modern sailors do not understand with their motors, cabins, and pinpoint-accurate radar. You don't simply go ashore when and because you want to. You don't quit a following wind. You don't do things for yourself. You do them for your boat and crew. If I really have to step ashore on the Wonder Strands, then I will have to come back on my own someday.

It is the time to celebrate, though. We're not at L'Anse aux Meadows yet—we've still got nearly three hundred miles to go—but our patience has finally paid off. Somewhere north of Nain we picked up a north wind and rode it for ninety miles. We've been screaming downwind ever since, resting nearly every other day.

Gone are the tensions of northern Labrador. They have been replaced with undeniable hope. There is probably no greater intoxicant than hope, especially to a bedraggled, tired crew of adventurers. Every face I look into is warmed by a smile. They are going home. They have accomplished what they set out to do. They have overcome a shaky leader, many sleepless nights, and their own ignorance.

Snorri lusts for the sea. Her sail swells with pride. And she appears indestructible.

This thought makes me laugh. Before this voyage began, I used to dream that my knarr would be crumbled by the first sizable wave. My sleep was consumed by such nightmares. Awake, I had the same thoughts. How could an open boat hold its own against the fierce, cold ocean? In my heart of hearts, I believed the Viking voyages were mere myth or perhaps the product of an incredibly lucky moment. These seas

could reach twenty-five feet or much, much higher. How could such a thinly planked boat withstand the pressures of a surging sea? I was sure it couldn't.

I remember one day in particular. I was flying between Maine and Boston in February. I glanced out the window of the plane and saw the ocean white and gray with rage. "God," I muttered aloud. "I hope I'm never out on a day like that."

Yet, here we are and we are loving it. *Snorri* was made for days like this. "Give me more wind. Let the seas rise," she taunts the gods. It is time for her to celebrate, too.

The gods respond. The skies grow dark and boisterous. The wind increases, and *Snorri* goes on the ride of her life. Finally, she feels unbound.

Snorri is headed home.

A little more than a week passes, and we finally reach L'Anse aux Meadows.

"There was no lack of salmon there in river or lake, and salmon bigger than they had ever seen before. The nature of the land was so choice, it seemed to them that none of the cattle would require fodder for the winter. No frost came during the winter, and the grass was hardly withered. . . ." So says the *Greenlanders Saga* about Leif Eriksson's Vinland. It goes on to relate a story about Leif's foster father finding grapes. Supposedly they gathered the grapes in the spring (an impossibility) and then set sail back to Greenland. "Leif gave the land a name in accordance with the good things they found in it, calling it Vinland."

If L'Anse aux Meadows is Vinland, all I can say is that Leif Eriksson was a better salesman than his dad. Erik the Red's calling the iciest island in the world Greenland was audacious, but it pales in comparison to calling this place grapeland. The trees are shrubbery. The river is at best a stream. The shallow "bay" is not a bay. It is unprotected

and crowded with rocks. The climate is horrendous. The grass may not have been withered in the winter, but it is right now in early fall.

Besides the outer coast of Baffin Island, this is the most weather-ravaged place we have seen. And one thing is certain, no grapes ever grew here.

Rob Stevens, our boatbuilder, turns to me and says, "They were blown across the Strait of Belle Isle. Got stuck and made the best of it."

The one positive aspect to this site is that if Leif and his gang arrived here, it had to have been devoid of any Native Americans. The Vikings would not have had to battle any indigenous people for the right to stay here—at least not at first. Why would indigenous people live right here if they didn't have to? A few miles southwest, plenty of trees and game abound. The only things that abound right here are rocks.

Like most historians, I am convinced that L'Anse aux Meadows is not Vinland. I am far from disappointed, however. I never really thought it was. It is, though, the only archeologically proven Viking settlement yet discovered. Whoever set up home here built a longhouse and a few storage buildings and workshops. More important, they made rivets, and so they obviously had a boat badly in need of repairs (further evidence for Rob's theory). The Vikings who came here, despite all its drawbacks, were more than happy to have found this spot. The local bogs provided iron, and the stream was their lifeblood. They needed this place.

So do we.

It has been our goal for four years. It is a destination that often seemed unattainable, at best. I could have picked a slew of theoretical sites from Ungava Bay, in northern Canada, to Cape Cod, but I know that arriving at any of them would not have produced the same emotions that are now welling within me. This place, because of its

link to the past and because of the hardships we have endured to get here, is divine. The replica sod huts, coming into view across *Snorri*'s bow as we kedge (haul on an anchor to move a boat forward in adverse conditions) our way closer and closer, look like home. The barren land is fitting. The cold wind invigorating. Goose bumps dance down my body, and my eyes water with delight, exhilaration, and even sadness.

This is the end.

Probably for the last time, all nine of us, worn out from the previous day's marathon rowing session and only two hours of sleep, stand in a line and pull home. Terry is leading us in our chantey, "Bound for L'Anse aux Meadows," and we're hauling with all our might. The rain is spitting at us, our hands are turning numb once again, the wind continues to fight us, yet we're singing and smiling.

Finally we pull *Snorri* in close enough to row the last hundred yards or so. The wind is making it difficult, but we want to get there on our own, even with a little dignity. So we bend our oars, and *Snorri* inches forward. The fights, the doubts, the recriminations—all are forgotten. Closer, closer *Snorri* moves.

There's a band on shore. We hear notes, laughter, an occasional cheer. We've reached our spot. We drop the anchor one last time and automatically go about our ritualized chores. Stow gear. Store the oars. Sweep the muck.

We stand on the foredeck together, looking puzzled. Now what? Then spontaneously we hug. Unforced, unexpected, and not a hint of awkwardness.

It's cold and wet, and the wind has risen. None of us wants to make the next move. The crowd is watching us expectantly. Unbeknownst to those on shore, we have decided to swim and wade our way to land, figuring it would be inappropriate for a

bunch of Vikings to be carted ashore in a modern dinghy. Suddenly, Dean rips off his shirt, and the crowd cheers in appreciation.

The next thing I know, I'm thrashing my way to solid earth, still in my Viking clothes. I stumble to shore and land in my wife's arms. My youngest daughter, Helen, is riding on her back. We hug ourselves close together.

I know that as I stand on that rocky shore and look back at *Snorri*, I have found my Vinland. There are no grapes. No trees. No salmon jumping at my feet. This Vinland is more than a place, more of a feeling than a settlement, as maybe it was all along.

It's not that we tried the impossible—as some people said it would be. It's not that we tried the never-before-done, sailing an open boat without a cabin or motor through the Arctic and subarctic; the Vikings did it plenty of times a thousand years before us. It's not that we tried to relearn skills that have been long-forgotten by our modern world, although we did.

It's simply that we tried.

So much of our lives are spent thinking about doing. Dreaming about the impossible. Fantasizing about sloughing it all off and really going for that one special thing. For a very brief moment we said, "Enough." For what was in fact a very small amount of time, we closed our eyes and jumped. That act, I now believe, is the mythical, elusive Vinland. We all need to go there sometime in our lives.

The band is playing. Kids are holding out papers to be autographed. Strangers are slapping me across the back. I have to go inside this smoke-choked sod house, stand by a warming fire, and try, for just a little while, not to let it all slip away.

I look one last time at *Snorri*. She looks proud. A ship of dreams.

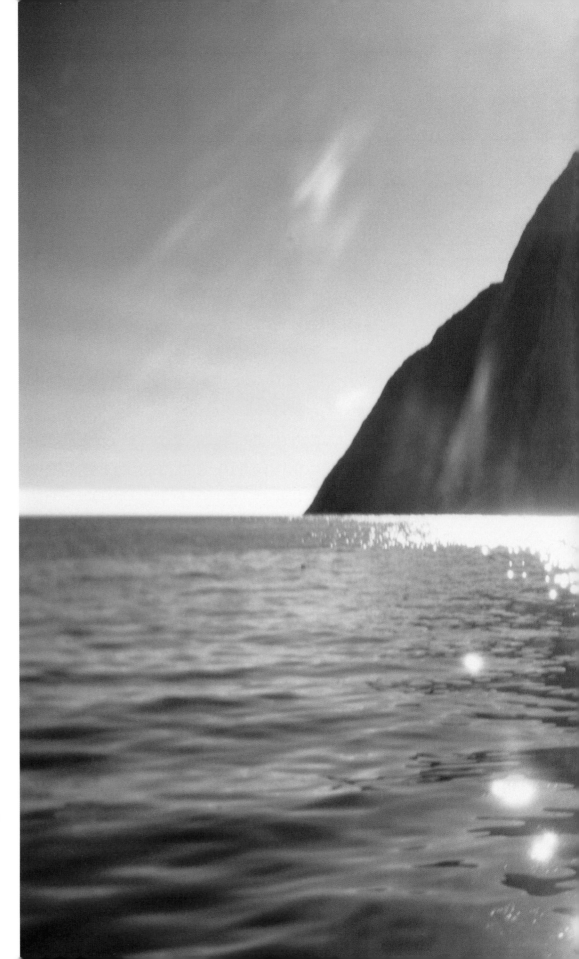

*Labrador, where
the mountains really
meet the sea.*

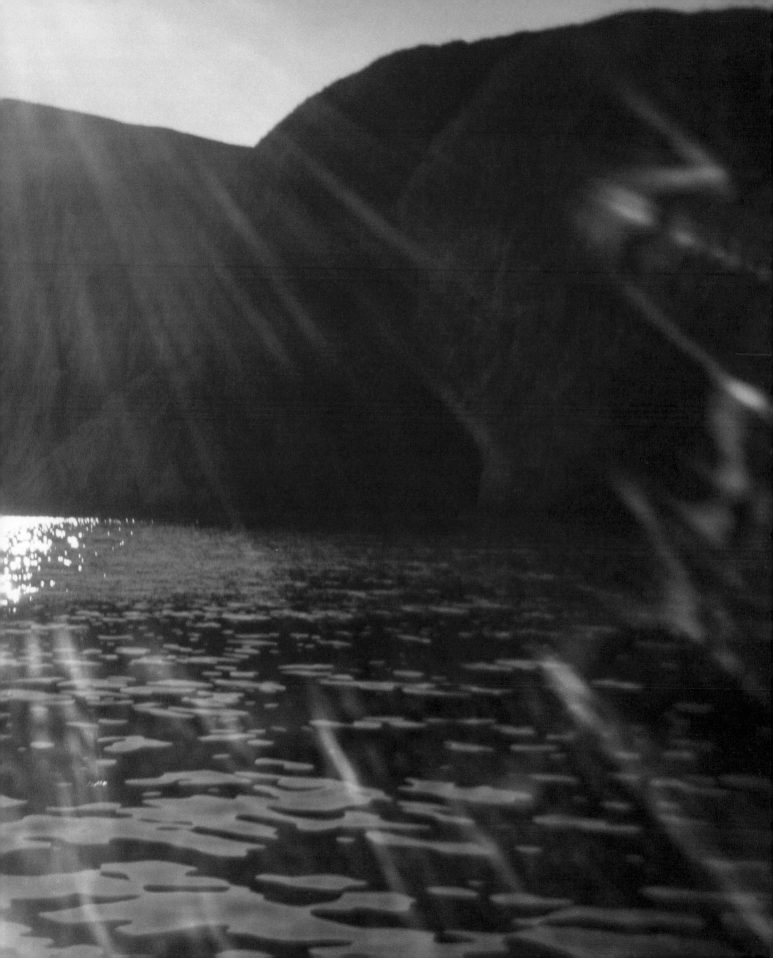

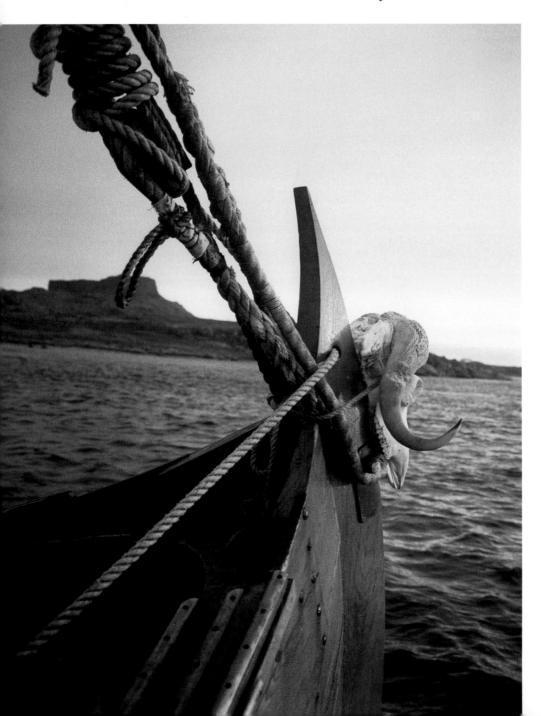

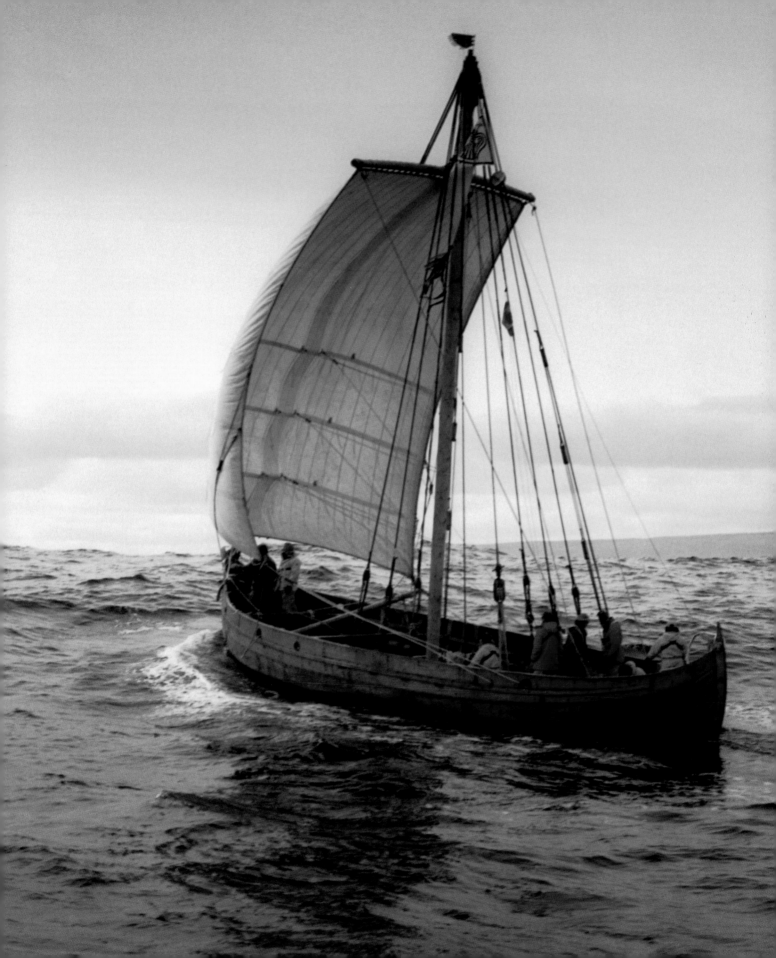

F. DWELLING, SHIP REPAIR AND IRON FORGING
HUTTE, RADOUB ET FORGEAGE

*The confirmed Viking settlement
at L'Anse aux Meadows—
was this the site of Leif's Vinland?*

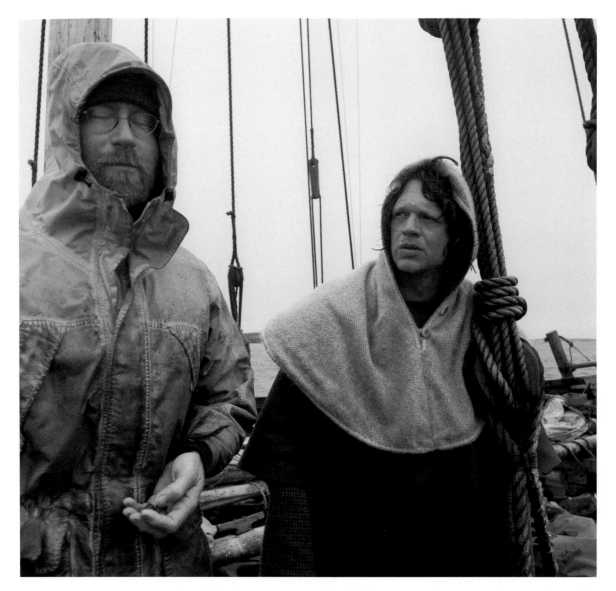

ABOVE:

*Modern versus Ancient. The Viking clothes—wool and leather—
outperformed modern gear. Here we are in the last moments of the
trip, before land was spotted.*

OPPOSITE:

*Families waiting atop Cape Onion for the first sight of Snorri
making her way across the Strait of Belle Isle for Newfoundland.*

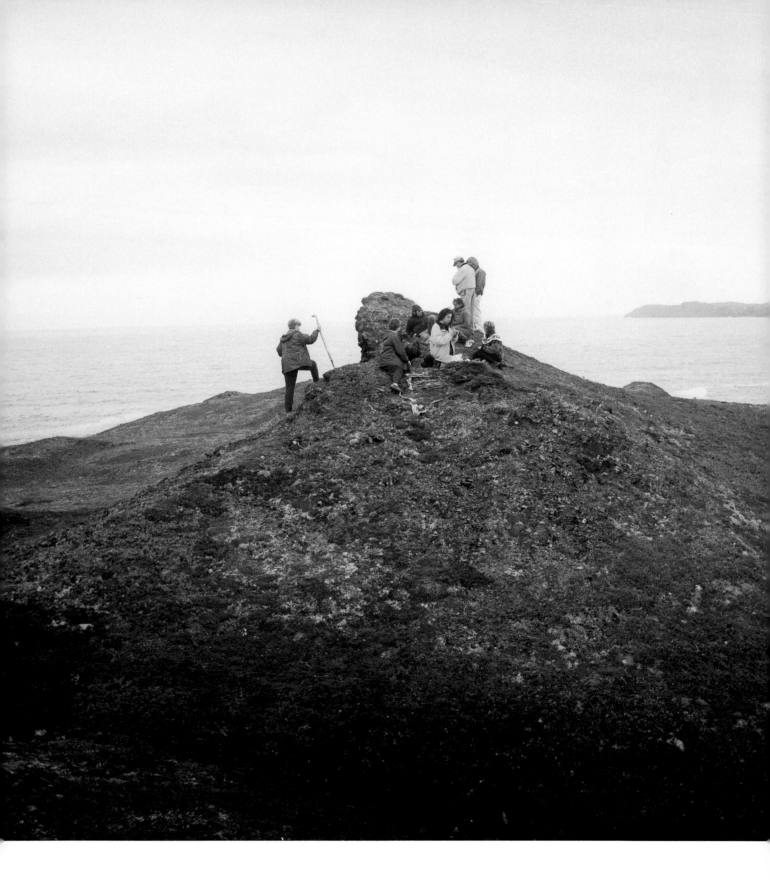

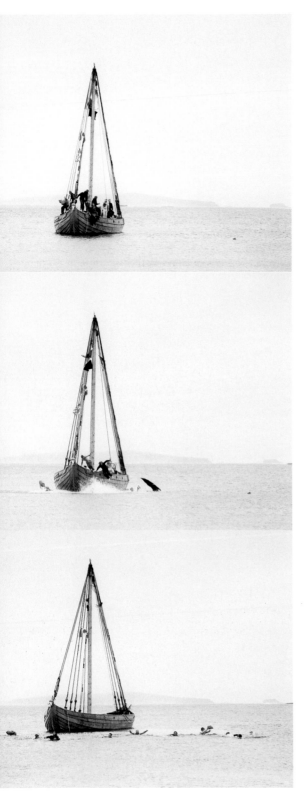

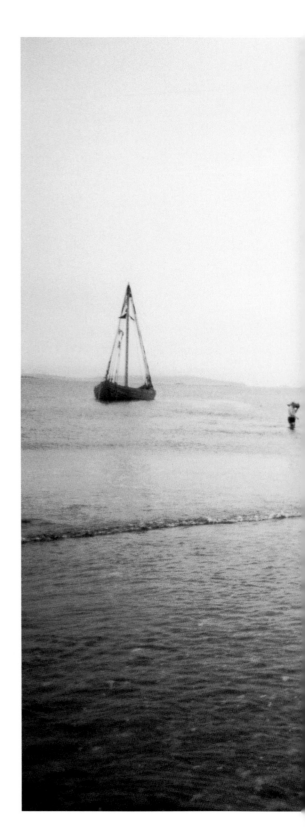

How to go ashore? In an inflatable dinghy or like real Vikings? The decision was easy, yet cold . . .

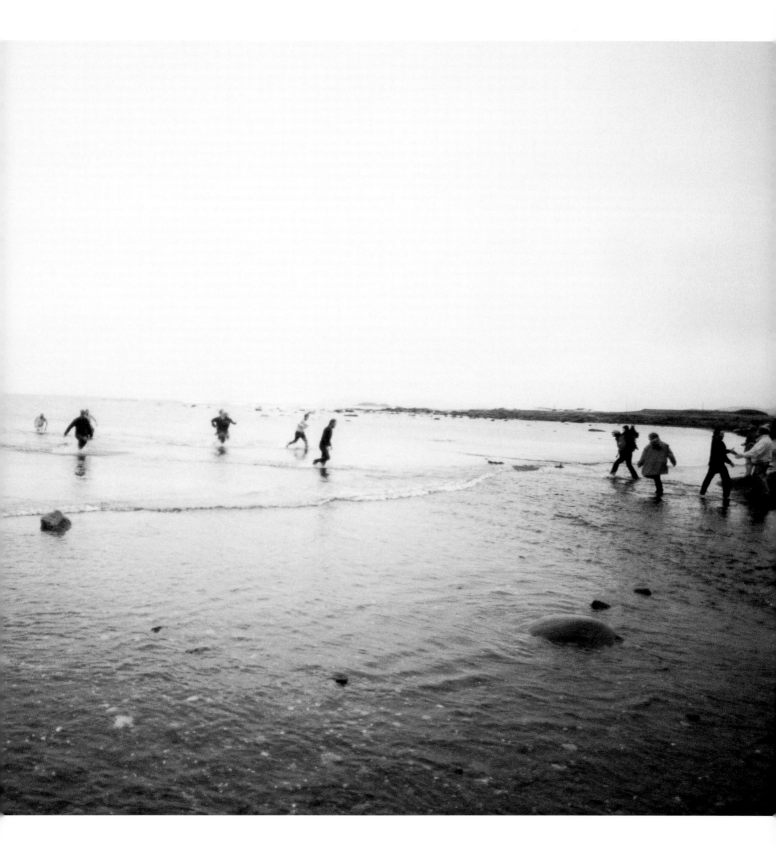

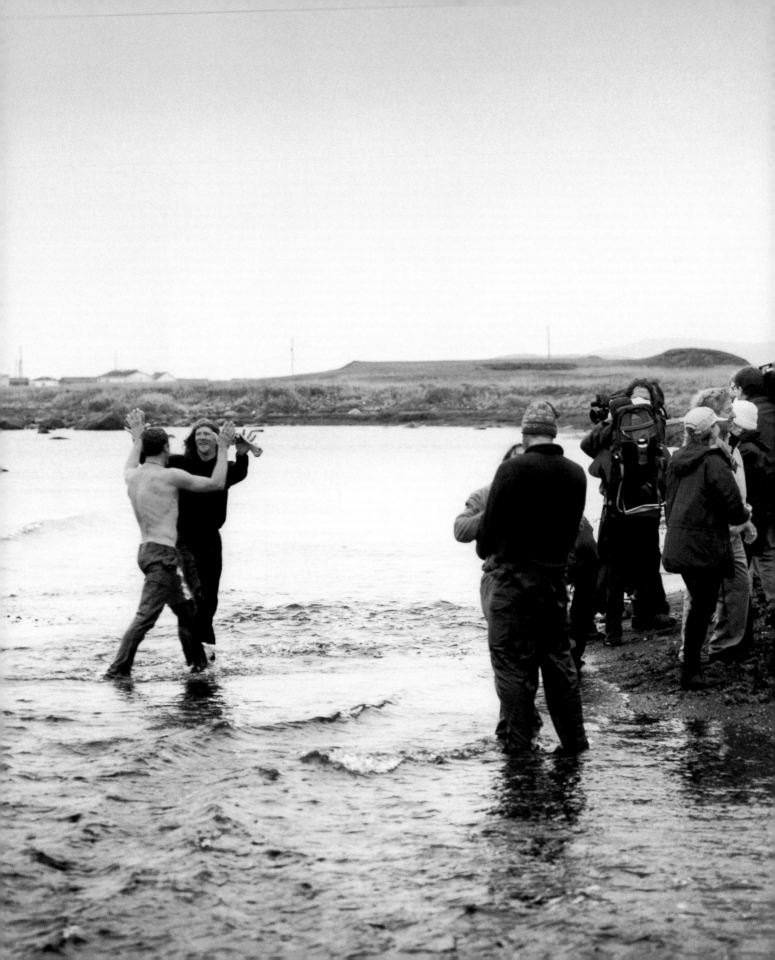

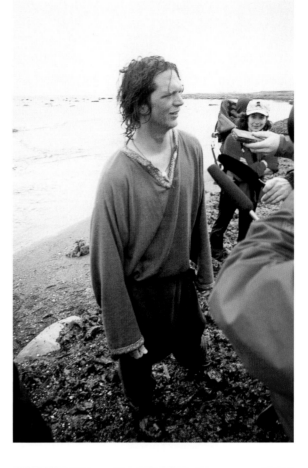

LEFT & RIGHT:

The modern world zooms in.

BELOW:

Hodding's wife, Lisa, and their daughter Helen, waiting for their celebrity Viking.

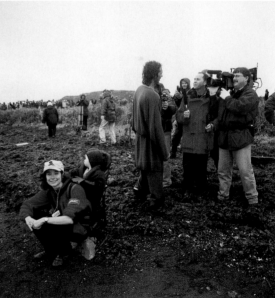

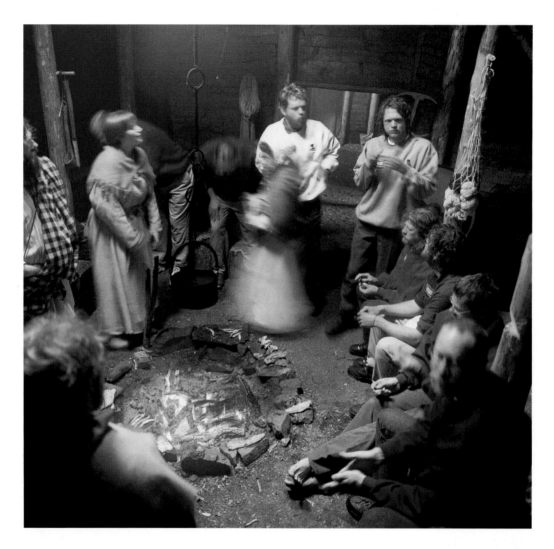

ABOVE & OPPOSITE:
*Inside the replica
sod house,* Snorri's *crew
meet their match.*
OVERLEAF:
L'anse aux Meadows

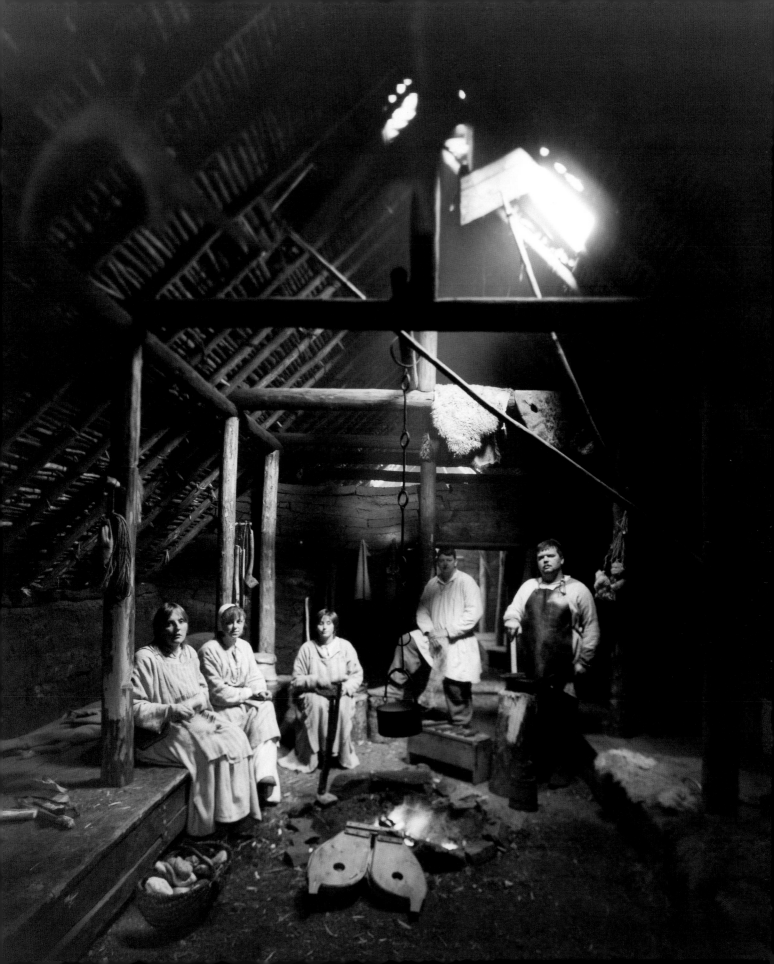

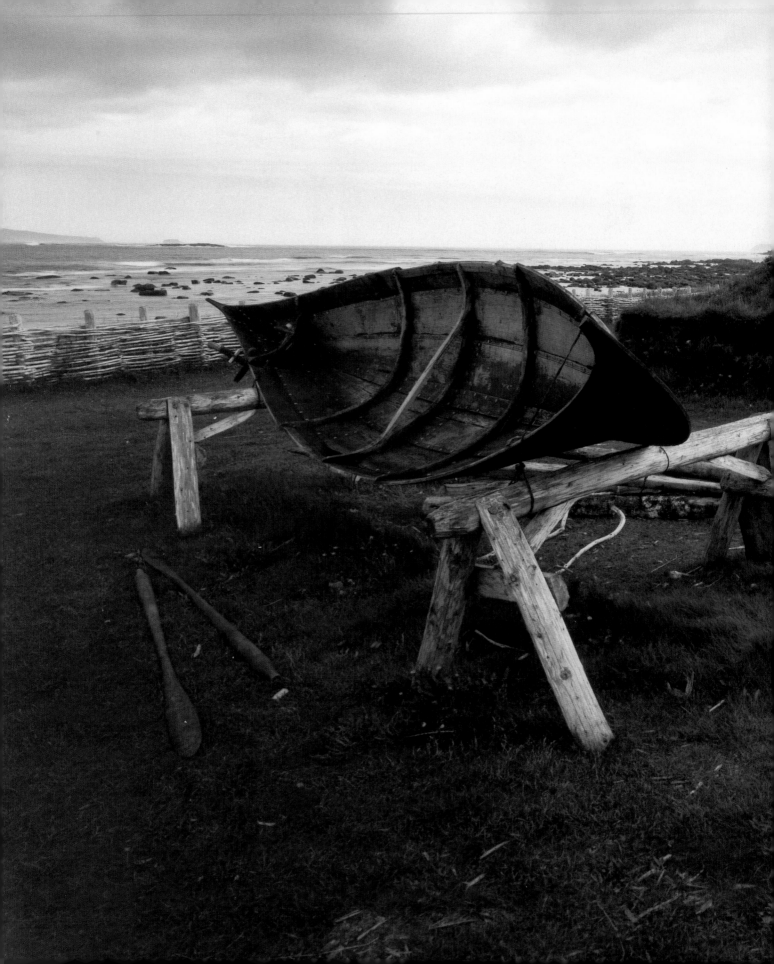

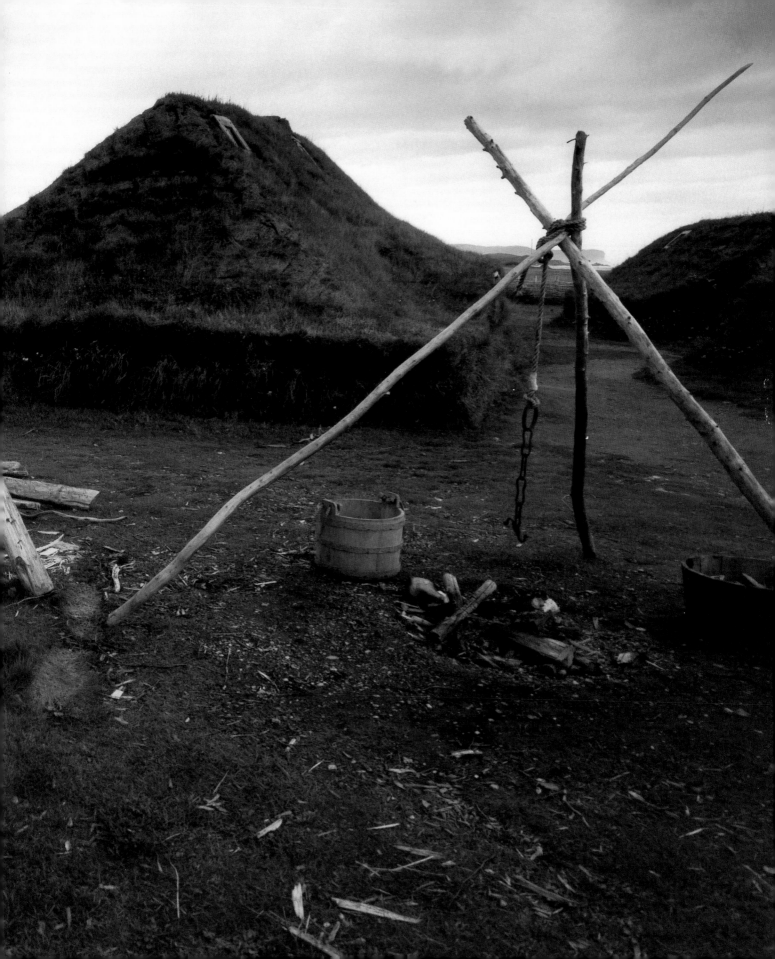

The end.